btacs

Cruise O Matic

D1290935

AUG 2 1989

First published in the United States 1988 by Chronicle Books.

English translation copyright © 1988 by Chronicle Books.

Copyright © 1987 by Graphic-sha Co., Ltd., Tokyo.

Printed in Japan.

Fifties American Magazine Ads. 1 – Automobiles by Yasutoshi Ikuta was first published in Japan by Graphic-sha Co., Ltd., Tokyo.

Library of Congress Cataloging-in-Publication Data

Automobiles. English.
 Cruise-o-matic : automobile advertising of the 1950s.

 Translation of: Automobiles.
 Originally published in series: '50s American.
magazine ads. ; 1.

 1.Advertising – Automobiles – United States.

2. Automobile industry and trade – United States – History.
I. Ikuta, Yasutoshi.

HF6161.A9A9713 1988 659.1'96292222'0973 88-11682
ISBN 0-87701-532-5

Edited by Heidi Fritschel
Cover design by Julie Noyes
English translation by Japan-Michi Institute

Distributed in Canada by Raincoast Books,
112 East 3rd Avenue, Vancouver, B.C.
V5T 1C8

10 9 8 7 6 5 4 3 2 1

Chronicle Books
275 Fifth Street
San Francisco, California 94103

Cruise O Matic

Automobile Advertising of the 1950s

YASUTOSHI IKUTA

Chronicle Books ● San Francisco

"TEST DRIVE" A '50 FORD!

SEE, HEAR AND FEEL THE DIFFERENCE

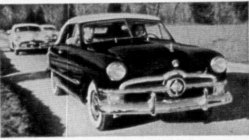

"IT SHINES ON DRESS PARADE...
IT PROVES ITS METTLE IN ACTION!"

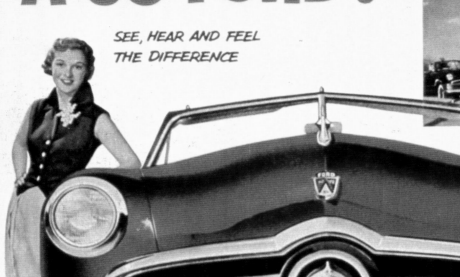

"IT'S GOT 'LET'S GO' STARTS
AND CAT'S PAW STOPS!"

Before you buy any car, your Ford Dealer invites you to "Test Drive" the '50 Ford! "Test Drive" it for power... for comfort... for ease of handling. As for economy—the rapidly growing family of '50 Ford owners has found that this car is designed for top value in original purchase price, and top economy of operation and maintenance. And for looks—well Ford has won the Fashion Academy's Gold Medal again for 1950! See it—"Test Drive" it at your Ford Dealer's today!

THERE'S A *Ford* IN YOUR FUTURE WITH A FUTURE BUILT IN !

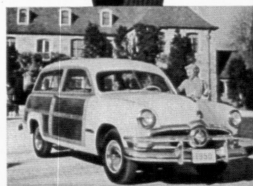

"IT TAKES THE MEDAL FOR BEAUTY
AND IT'S BUILT TO LIVE OUTDOORS!"

'50 Ford

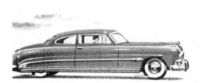

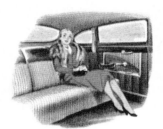

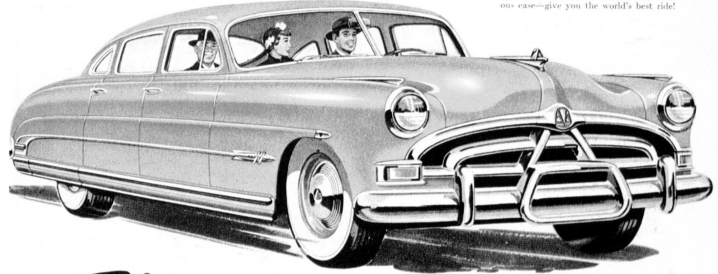
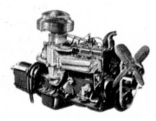

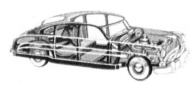

The New

DE SOTO
Fire Dome 8

With its mighty 160 h.p. V-Eight Engine...Power Steering...Power Braking...and No-Shift Driving...it is the most revolutionary new car of 1952. See and *drive* it!

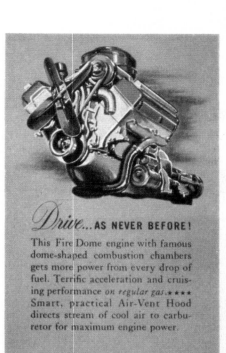

Drive...AS NEVER BEFORE!

This Fire Dome engine with famous dome-shaped combustion chambers gets more power from every drop of fuel. Terrific acceleration and cruising performance *on regular gas.*★★★★ Smart, practical Air-Vent Hood directs stream of cool air to carburetor for maximum engine power.

Steer...WITHOUT EFFORT!

Power Steering is easy as dialing a telephone...you can turn wheel with one finger. Hydraulic power does the work. Parking is *easy!*

DE SOTO DIVISION, CHRYSLER CORPORATION

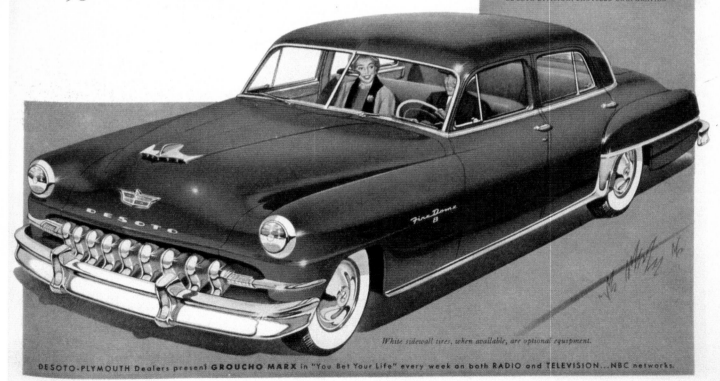

White sidewall tires, when available, are optional equipment.

DESOTO-PLYMOUTH Dealers present GROUCHO MARX in "You Bet Your Life" every week on both RADIO and TELEVISION...NBC networks.

'52 De Soto Fire Dome 8

Longest "Holiday" of the Year!

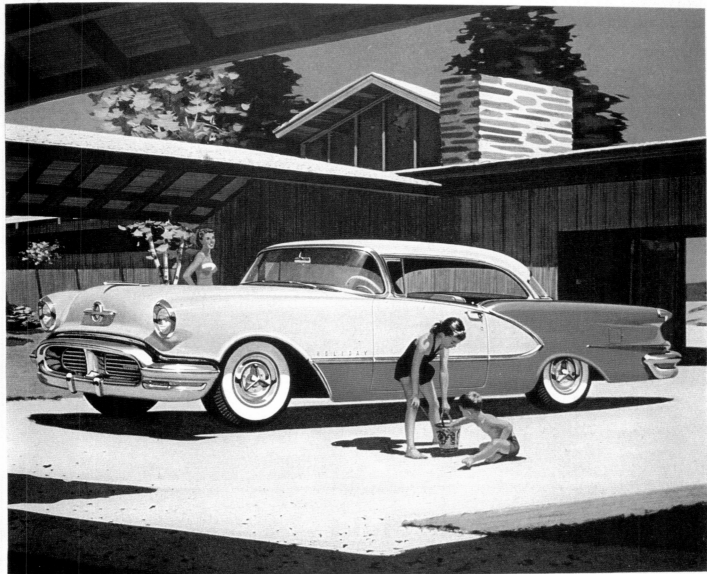

NINETY-EIGHT DE LUXE HOLIDAY COUPÉ

▶ Right now . . . and through every month to follow . . . this Oldsmobile Ninety-Eight De Luxe *Holiday* Coupé lives up to its name. For indeed, it is powered high, styled low and long, to add a vacation-like zest to driving. Its Rocket T-350 Engine is always ready with a safety reserve of power to make short, easy work of any trip. The relaxing smoothness of Jetaway Hydra-Matic Drive is yours, too . . . and the effort-saving precision control of Safety Power Steering. This car cuts a proud figure . . . at ease in your driveway or in action on the road. Your Oldsmobile dealer suggests that you inspect it carefully, drive it critically. And this is an experience to be enjoyed *right now!*

NINETY-EIGHT
BY
Oldsmobile

A QUALITY PRODUCT BROUGHT TO YOU BY AN OLDSMOBILE QUALITY DEALER

'56 Oldsmobile 98 Holiday Coupe

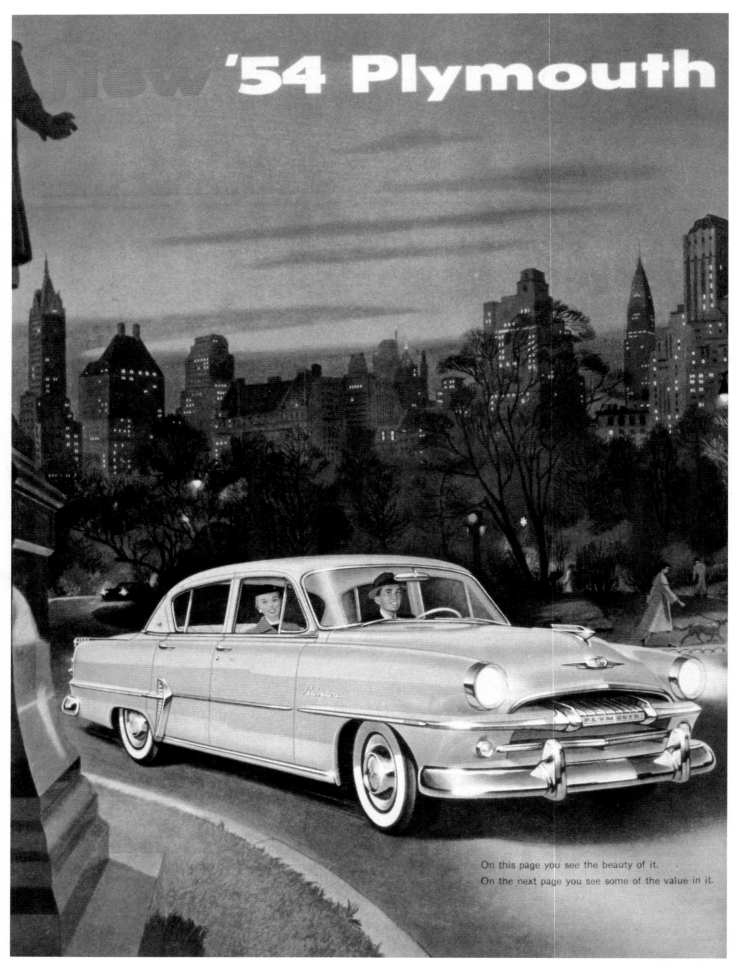

now '54 Plymouth

On this page you see the beauty of it.
On the next page you see some of the value in it.

'54 Plymouth

8

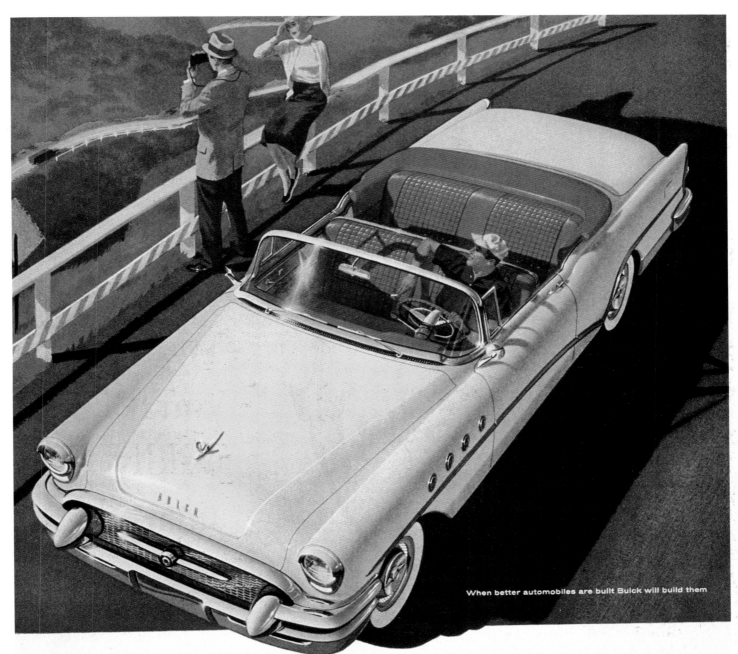

When better automobiles are built Buick will build them

Why not make a smart move — just for the fun of it?

IT makes good sense, if you like the finer things in life, to go looking where the cream lies thickest.

In motoring, that means a meeting with ROADMASTER — and for a very sound reason.

This top-of-the-line Buick is the very cream of the most successful line of Buicks in all history — with sales now soaring to an all-time best-seller high.

That brings to the buyer of a ROADMASTER many things not to be had in other fine cars of similar stature.

For the advantages that are bringing such soaring success to *all* Buicks are merely the beginnings for ROADMASTER.

Here, the great Buick ride of all-coil springing is made measurably better by larger tires, by bigger brakes, by special cushioning in the car's interior.

Here, exclusive fabrics and finish are fully in keeping with the custom production status of this luxurious automobile.

And here, as you would expect, is a long list of items provided as standard equipment at no extra cost — including Buick's much-wanted Safety Power Steering.

But this year, the move to ROADMASTER is a smarter move than ever in the fine-car field — because here you get the most modern automatic transmission yet developed.

It is the new Variable Pitch Dynaflow — smooth to the absolute — improved in gasoline mileage — thrilling beyond all previous experience when you call for action. And it is given life by the highest horsepower ever placed in a Buick.

So may we suggest that you look into ROADMASTER — just for the fun and satisfaction it can bring you? Your Buick dealer will gladly arrange matters — and show you the sensible price that Buick's volume production permits for this custom-built automobile.

BUICK *Division of* GENERAL MOTORS

ROADMASTER
Custom Built by Buick

'55 Buick Roadmaster

The *New* PACKARD

WITH TORSION-LEVEL RIDE

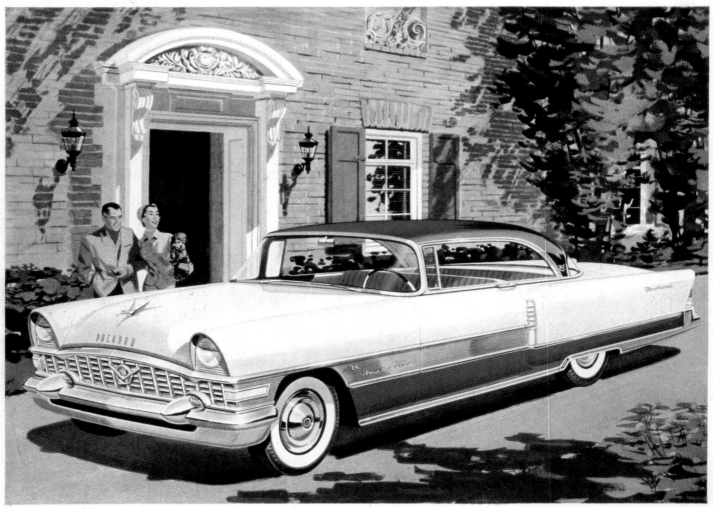

THE NEW PACKARD 'FOUR HUNDRED'—"ASK THE MAN WHO OWNS ONE"

Greatest Ride Development in Automotive History

PRIDE OF possession—a gleam in the owner's eye . . . ardent admiration—a gleam in *other* eyes . . . this is the impression the *new* Packard is making on owner and onlooker, alike!

Packard engineers, in common with Packard designers, had exclusiveness as their objective. For *only* Packard has Torsion-Level Ride which eliminates coil and leaf springs . . . smooths the road . . . levels the load—*automatically!* In other cars the twisting forces of wheel shock are sent to the frame, creating pitch and bounce

and wracking of the frame and body. In Packard, these same forces are transmitted along the new suspension system and absorbed *before* they reach frame or passengers. And an ingenious power-controlled levelizer keeps the *new* Packard always at "flight-level" regardless of load.

Packard owners can be proud of more than the ride. A new "free-breathing" V-8 engine, 275 horsepower in the Caribbean, 260 in all other models, delivers more driving force to the rear wheels, at all road speeds, than any other

American passenger car engine. And new Packard Twin Ultramatic is the smoothest, most alert of all automatic transmissions.

Gracefully contoured and luxuriously appointed, here is the *one* new car in the fine car field. Your Packard dealer will be happy to place the keys to a *new* Packard at your disposal . . . drive it and *let the ride decide!*

Take the Key and See

PACKARD DIVISION • STUDEBAKER-PACKARD CORP.

'56 Packard 400

This is the Eldorado—a new adventure in automotive design and engineering—with brilliant and dramatic styling . . . hand-crafted, imported leather interiors . . . "disappearing" top . . . and a sensational 270-h.p. engine. In all that it is, and does, and represents . . . it is the finest fruit of Cadillac's never-ending crusade to build greater quality into the American motor car.

Now in limited production • Price on request

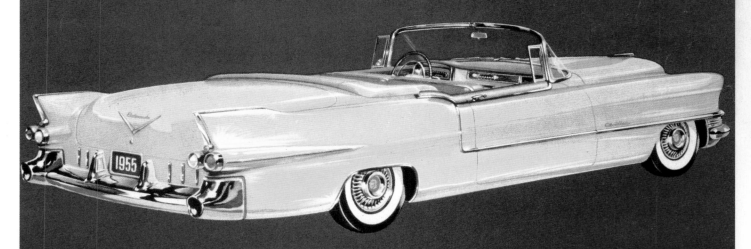

Eldorado

BY CADILLAC

CADILLAC MOTOR CAR DIVISION • GENERAL MOTORS CORPORATION

'55 Cadillac Eldorado

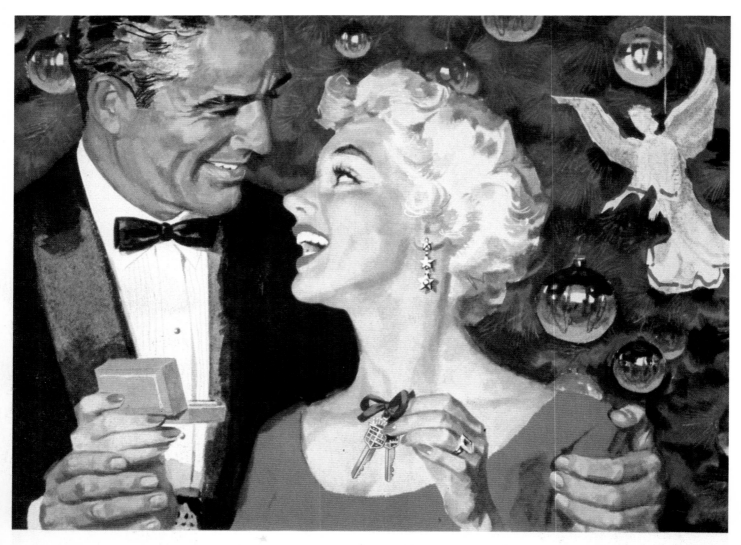

The Christmas They'll Never Forget!

Cadillac

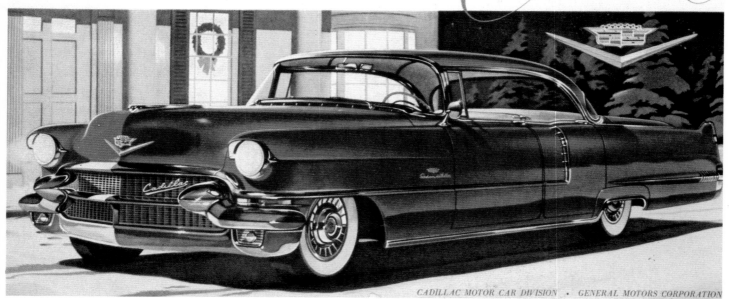

'56 Cadillac Fleetwood

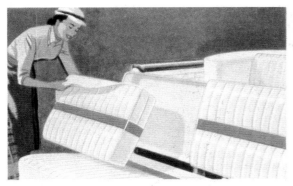

° – The seats of the Caribbean series cars are reversible and they strikingly new note to the beauty of the car's interior. Here, plump, leather fits perfectly into the outdoor sports picture.

° – On more formal occasions, the beautiful brocade fabric is espe- appropriate. Notice the ingenious and practical separation between omfort-contoured seat cushions and back rests.

° – Packard's Electronic Push-Button Control is the ultimate in matic motoring. You select gears by simply pressing a button and the onse is electronically swift, smooth and sure.

For 1956 Packard Presents
America's easiest-handling,
safest-riding car…

And certainly the Smartest!

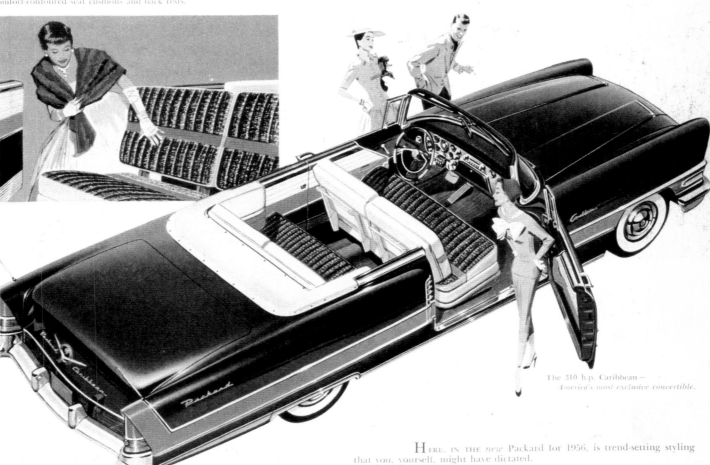

The 310 h.p. Caribbean —
America's most exclusive convertible.

HERE, IN THE *new* Packard for 1956, is trend-setting styling that you, yourself, might have dictated.

Typical of this brilliant Packard touch are the Caribbean seats, the first reversible seats in any automobile. They are as new and original and finely fashioned as a decorator's smartest creation . . . and they permit you to change your car's decor from sleek leather to glowing fabric at the flip of a cushion.

Naturally, Packard's performance is on a par with its style. Packard's advanced Torsion-Level Ride offers comfort, handling ease and safety that no car relying on coil and leaf springs can even approach. America's most powerful V-8 engine puts 310 horsepower at the tip of your toe. Packard's Ultramatic, smoothest and swiftest of all automatic transmissions, now enables you to select gears by simply pushing a button on its Electronic Push-Button Control panel.

Your dealer invites you to drive the limited edition Caribbean, the regal Patrician, the care-free Four Hundred. When you do, we believe you'll agree that this is *the greatest Packard of them all* . . . America's easiest-handling, safest-riding car, and certainly the smartest!

PACKARD DIVISION • Studebaker-Corporation
Where Pride of Workmanship Still Comes First.

'56 Packard Caribbean

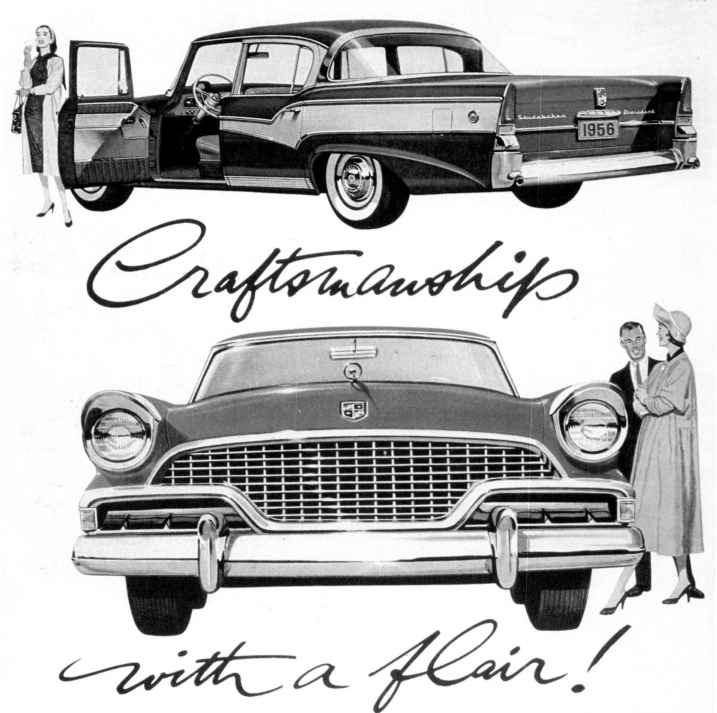

Craftsmanship

with a flair!

Here's the look of luxury—and it's in the *low price field!* It's the big new Studebaker—and never before has there been such a difference in low price cars. Here's why:

You get the longest wheelbase—120½ inches—and the biggest power—210 hp.—in its class. You get a fabulous floating ride,

along with silky bursts of speed that only the costliest cars can rival.

And from its massive new grille to its high-falutin' dual exhausts, you get beauty. Inside, surrounded by lovely color-keyed interiors, soothed by a sound-conditioned ceiling, you get luxury beyond compare.

Yes, only Studebaker brings you new style, new power, new beauty—*Craftsmanship with a Flair* in the low price field! There are 16 new and different models for you to choose from: beautiful passenger cars, *big* station wagons, exciting family-sports cars. See them at your Studebaker Dealer's soon!

Studebaker
THE BIG NEW CHOICE
IN THE LOW PRICE FIELD

STUDEBAKER DIVISION, STUDEBAKER-PACKARD CORPORATION—WHERE PRIDE OF WORKMANSHIP <u>STILL</u> COMES FIRST!
Tune in TV Reader's Digest every week.

'56 Studebaker

14

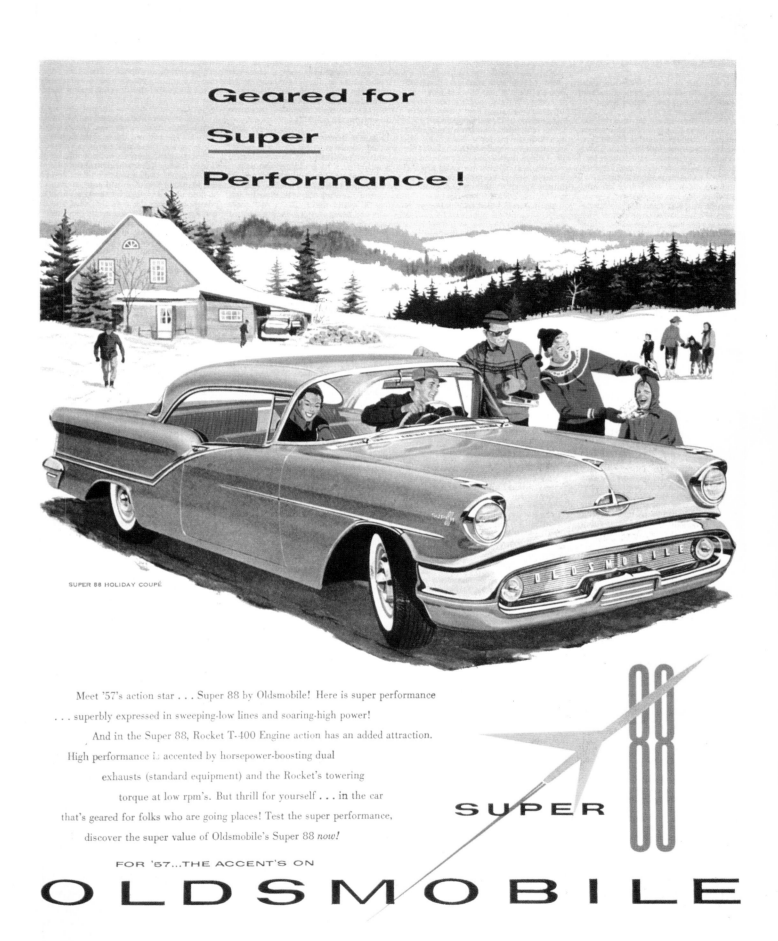

Geared for
Super
Performance!

SUPER 88 HOLIDAY COUPÉ

Meet '57's action star . . . Super 88 by Oldsmobile! Here is super performance
. . . superbly expressed in sweeping-low lines and soaring-high power!

And in the Super 88, Rocket T-400 Engine action has an added attraction.
High performance is accented by horsepower-boosting dual
exhausts (standard equipment) and the Rocket's towering
torque at low rpm's. But thrill for yourself . . . in the car
that's geared for folks who are going places! Test the super performance,
discover the super value of Oldsmobile's Super 88 now!

SUPER 88

FOR '57...THE ACCENT'S ON

OLDSMOBILE

'57 Oldsmobile Super 88

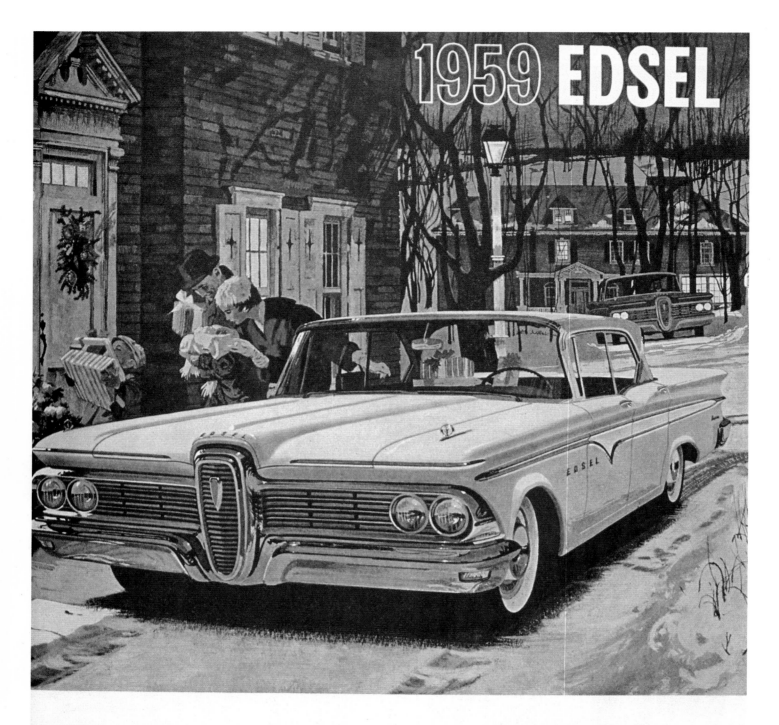

1959 EDSEL

Half its beauty is its new, low price!

Makes history by making sense

Exciting new kind of car! Plenty of room for six. Plenty of power without hogging gas. Soundly engineered. Solidly built. And priced with the most popular three!

This is the car built with a shrewd buyer in mind—a car that really makes sense! Crisp, clean lines give you the kind of distinction that's always in style. Sound engineering provides generous six-passenger room without useless length, and gives you four new mileage-minded engines—including a thrifty six and a spirited new V-8 that uses *regular* gas! Price? A new Edsel Ranger is priced almost exactly the same as many models of Plymouth, Chevrolet and Ford! This comparison is based on actual factory suggested retail prices. See for yourself. At your Edsel Dealer now.

EDSEL DIVISION · FORD MOTOR COMPANY

For America the decade of the 1950s, or more simply just the fifties, was a wonderful time.

Not only was America taking a leading role in world politics; it was glorifying in unparalleled economic prosperity. The income of Americans was climbing year by year and the standard of living rose steadily. Technological innovations were resulting in the marketing of more appealing products, and to disseminate these goods advertising poured forth from the pages of magazines and newspapers.

Advertising took the middle class in its everyday, American way of life, and illustrated a happy slice of it. Two cars and a carpeted home in the suburbs was the ideal of the average American of the times, but this ideal was nowhere more clearly evident than in magazine advertising. The powerful influence of advertising on the American society of the fifties rivaled even that of education and religion.

This book is a visual retrospective of magazine advertising through the decade of the fifties. The five representative text and picture weeklies of the day — *Life, The Saturday Evening Post, Collier's, Look,* and *Holiday* — provided most of the advertising illustrations appearing in this edition. Only illustrations that are thought to have best exemplified the atmosphere of the times were selected and, fading and discoloration not withstanding, reproduced as far as possible in their original form and color.

Thus, more than a collection of advertising "masterpieces" or a "best works" edition, this retrospective attempts to bring forth the glory of the fifties through a presentation of the best automobile advertising of the period.

The decade of the 1950s was the golden age of the American automobile industry. America enjoyed a monopolistic prosperity, while scorning the European automobile-manufacturing countries, which had been left exhausted by World War II. The full-sized car made in Detroit, with its powerful V-8 engine in a big, five-meter-long body, symbolized the wealth and clout of the American superpower.

The Rolling Jukebox

The most identifiable feature of American cars of the 1950s was the soaring tail fin, which made its first appearance on the 1948 Cadillac. At the outset, within General Motors itself, those who opposed this innovation outnumbered whose who thought it would sell. The consumers, however, loved it. The style perfectly matched not only the upsurge of nationalism in the United States, which, after weathering both World War II and the Korean War had risen to become the number-one superpower in the world, but also the boldness that Americans exhibited in general.

Thus, with each year's new model the tail fin became larger and more exaggerated. Its most extreme manifestation graced the 1959 Cadillac. Moreover, from about 1955 on, cars made by GM's competitors began to resemble Cadillacs, for the majority of cars produced after the mid-fifties bore the fashionable tail fin.

Another unmistakable characteristic of American cars of the fifties was their shiny chromium plating. In addition, striking primary colors like red, yellow, and blue became popular for car body coloration. American cars had tended to be excessively decorated ever since the twenties, and the material prosperity America enjoyed during the fifties caused the tendency to spread rapidly.

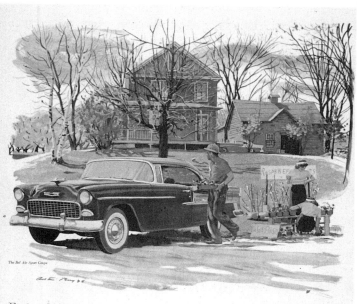

The Bel Air Sport Coupe

Fresher than springtime!

Gayer than the first bright flowers!

With a new V8 and two new 6's to choose from!

What could turn a young man's fancy
to thoughts of love
quicker than the new Chevrolet!

A realist might say that a young lady is more likely to arouse thoughts of love than an automobile. But it would be obvious to the informed that a realist with such a literal outlook had never commanded a new Motoramic Chevrolet with a "Turbo-Fire V8" (or with one of the new 6's) under its bonnet!

For here is an experience in plus-power that will delight the senses as fully as the long, low lines of the new Chevrolet will delight the eye. . . . There are many new features about the new Chevrolet that the cold-minded will embrace with all the logic and reason at their command . . . just as Chevrolet's fresh styling and gay colors and great power will send the fanciful soaring! Won't you take the time to see and drive the new Chevrolet? Chevrolet Division of General Motors, Detroit 2, Michigan.

Motoramic **CHEVROLET** *Stealing the thunder from the high-priced cars!*

The 1950s saw the proliferation of the large V-8 engine. In 1950, only a little over 40 percent of American cars had V-8 engines. At that time, it was commonly held that V-8 engines were for high-class cars and V-6 engines were for middle-class cars and cars for the general public. Like the tail fin, however, the engine rapidly got larger. In 1953 50 percent of all cars had V-8 engines; by 1957 that number had grown to 80 percent.

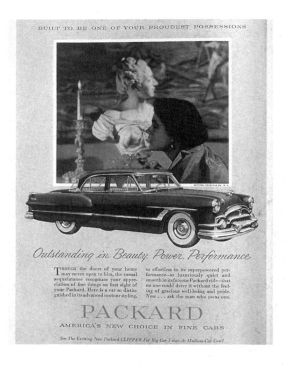

BUILT TO BE ONE OF YOUR PROUDEST POSSESSIONS

Outstanding in Beauty, Power, Performance

Though the doors of your home may never open to him, the casual acquaintance recognizes your appreciation of fine things on first sight of your Packard. Here is a car so distinguished in its advanced contour styling, so effortless in its superpowered performance—so luxuriously quiet and smooth in its famous Packard ride—that no one could drive it without the feeling of gracious well-being and pride. Now . . . ask the man who owns one.

PACKARD

AMERICA'S NEW CHOICE IN FINE CARS

See The Exciting New Packard CLIPPER For Big-Car Value At Medium-Car Cost!

Announcing the great new 58 FORD

PROVED AND APPROVED AROUND THE WORLD

A new car rolled out of Detroit one day last July, bound for the greatest adventure in motor car history. The car: the 58 Ford. The assignment: to test the performance and dependability of this new car around the world . . . if possible.

The route was the most rugged that could be laid out. After London and Paris came the Alps; after Rome came Yugoslavia's rockbound seacoast; after Istanbul came the camel-tracks of Iran and Afghanistan; then the Khyber Pass through the Himalayas, the bullock-trails of India, the jungle roads east to Vietnam. Weather: worse than you'll ever encounter—122° heat, sandstorms, and 24-hour-a-day rains.

The 58 Ford rolled beautifully, easily through the severest road test ever given a car *before* its American announcement. The Ford *endured*—and came through still glittering and fresh.

Acclaimed from Buckingham Palace to the Taj Mahal, it showed camels how to cross deserts and elephants how to move through jungles. It was *proved* and *approved* by everyone from natives who had never seen an American car before to famous stylists and nabobs who have seen every car built.

Never before has such a trip been made. This round-the-world performance test became a victory parade, from London to Saigon and back to Detroit. Again, in the Ford tradition, the 58 Ford has broken a trail far out beyond competition.

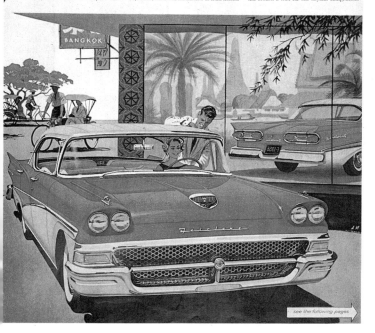

see the following pages

Cars as Status Symbols

In the America of the 1950s, a car was not only a means of transportation, but a symbol of its driver's status and personality as well. Each make of car had a specific image that led drivers to buy it.

For example, Cadillacs and Imperials were cars for managers; Buicks and Packards were for intellectuals like doctors, lawyers, and college professors; Pontiacs were for school teachers; and Nashes were for housewives. People started to upgrade their cars as their social status rose.

A friend of mine who studied in the United States was once told by an American professor, "In this country, there is only one way to judge people: see what kind of car he drives. Now that doesn't mean that those who drive high-class cars are always high-class people, but those who drive low-class cars are without doubt low-class people. Watch out for them!"

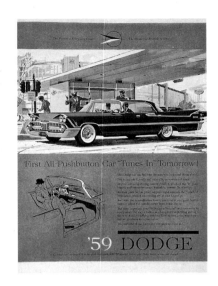

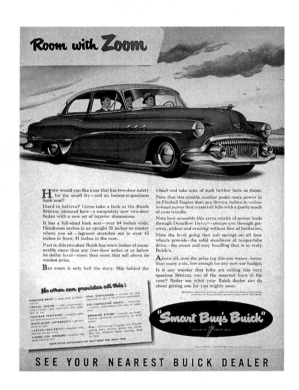

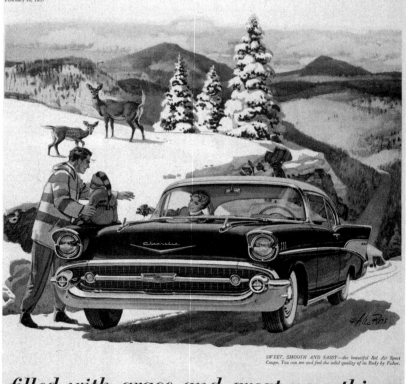

The American automobile industry reached its apex during the 1950s. Production records in Detroit constantly achieved new heights, and by 1955 the number of U.S. domestic new car registrations had reached 7,170,000.

Even with such strong overall growth, the monopoly of the big three manufacturers — GM, Ford, and Chrysler — steadily progressed. Although independent automakers such as Hudson, Kaiser-Frazer, Nash, Packard, Studebaker, and Willys challenged the giant manufacturers in a last-ditch struggle to survive, their market shares continued to slide. In 1955 Kaiser and Willys disappeared; in 1957, Hudson and Nash; and in 1958, Packard.

The big three automakers also had to fight hard for their shares of the market. In 1957 the Edsel, introduced to the market by Ford with a huge promotional campaign, sold poorly. (The number of registrations of the new car was 26,000 in the first year, 38,000 in 1958, and 40,000 in 1959.) Production stopped after only three years. The annual sales of Chrysler's De Soto dropped sharply around 1958, and its production was halted in 1960.

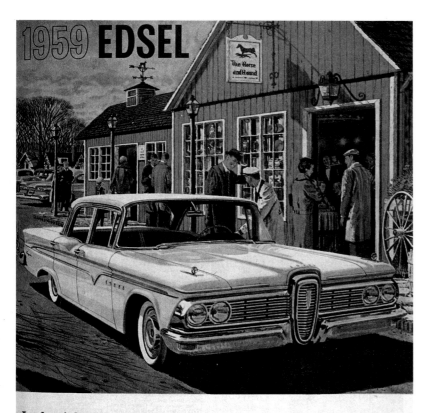

1959 EDSEL

The Horse and Hound

Looks right! Built right! Priced right!

Makes history by making sense

Exciting new kind of car! A full-size, six-passenger beauty. Roomy without useless length. Built to last. Powered to save. And priced with the most popular three!

Here's the kind of car you hoped would happen. All the spacious luxury you could ask for—yet much easier to park and drive. Because Edsel's new styling sensibly called for *less length* this year! And

Edsel engineering sensibly planned for all the power you can use—but with *real gas savings* every mile! Edsel's four new engines include an efficient, thrifty six and a new, economy V-8 that does you proud

on *regular fuel!* It all makes sense—and so does the new, low price. *For the 1959 Edsel is actually priced with the most popular three—Ford, Plymouth and Chevrolet!*
EDSEL DIVISION · FORD MOTOR COMPANY

FOR YOUR FALL CHANGE ... see my dad !

The Signs of the End of the American Age

Beginning in about 1957, signs of a serious change of affairs began to appear in the prosperous United States. That year the Russians launched the space satellite *Sputnik;* in 1958 there was an economic recession, deficits appeared in the international balance of trade, and Europe regained lost power. Incidents like these cropped up to suggest that the end of Pax Americana was at hand.

At the same time a distinct change appeared in the automotive industry as well. The gaudy, overdesigned cars with their poor gas mileage began to lose popularity. Americans started showing an interest in the economical European small cars that boasted good gas mileage. The small imports, which were not included in the 1955 statistics, appeared in 1957 with a sales figure of 210,000, in 1958 with 380,000, and in 1959 with 610,000. By the end of the 1950s, small cars represented 10 percent of all U.S. new car registrations.

Naturally, somewhere among that 10 percent could be found the small cars from Japan — Toyota and Nissan — although the actual number sold was still negligible. But throughout the 1960s and 1970s, Japanese cars gradually increased their market share, finally almost monopolizing the American imported car market, and contributing to today's U.S.-Japan trade war. This trend toward increased sales of the small imported car that started late in the 1950s portended the end of the age of the full-sized car from Detroit.

Today, we rarely see these colorful, chrome-bedecked cars outside of advertisements like those shown in this book. The car that so well symbolized the American glory of the 1950s has disappeared into the pages of history.

1955 U.S. New Car Sales
Quantity & Rank of Various Makes

Make	Rank	Quantity	Share
CHEVROLET	1	1,640,681	22.9%
FORD	2	1,573,276	21.9%
BUICK	3	737,879	10.3%
PLYMOUTH	4	647,352	9.0%
OLDSMOBILE	5	589,515	8.2%
PONTIAC	6	530,007	7.3%
MERCURY	7	371,837	5.1%
DODGE	8	284,323	3.9%
CHRYSLER	9	144,618	2.0%
CADILLAC	10	141,038	1.9%
DE SOTO	11	118,062	1.6%
STUDEBAKER	12	95,761	1.3%
NASH	13	93,541	1.3%
PACKARD	14	52,103	0.7%
HUDSON	15	43,212	0.6%
LINCOLN	16	35,017	0.5%
IMPERIAL	17	11,840	0.2%
WILLYS	18	6,267	negligible
KAISER	19	959	negligible
CONTINENTAL	20	606	negligible

Total Sales $7,169,908

(Source: Automotive News Almanac)

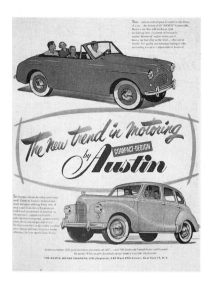

1950

◄Chevrolet, Chrysler, Dodge, and De Soto all begin to sell hardtops.
◄The 3 millionth Oldsmobile comes off the assembly line. Oldsmobile completely stops manufacturing a 6-cylinder car and installs 8-cylinder engines in all models.
◄The Chrysler Company celebrates its twenty-fifth anniversary.
◄The Korean War prompts U.S. military authorities to grant large contracts to all automotive manufacturers for the production of military vehicles.
◄The 1951 models are introduced. Many have V-8 engines, automatic transmissions, and curved windshields.

1951

◄Chrysler and Buick introduce cars with power steering.
◄The Willys-Overland Company introduces the Aero-Willys as its postwar model.
◄The Kaiser-Frazer Company announces the cessation of production of the Frazer car.
◄ In December, the 100 millionth American automobile comes off the assembly line.

1952

◄The Studebaker Company celebrates its 100th anniversary.
◄The GM Cadillac division celebrates its fiftieth anniversary.
◄The Chrysler Crown Imperial is given a 12-volt battery with AC dynamo.
◄The Hudson Jet debuts.
◄The Willys-Overland Company introduces two new models: the Arrow Ace and the Arrow Lark.

1953

◄Both the GM Buick division and the Ford Company celebrate their fiftieth anniversaries.
◄Kaiser-Frazer changes its company name to Kaiser Motors. In addition, the company buys out Willys-Overland.
◄Automatic transmission becomes an option in almost all models; moreover, it becomes a standard installation for high-priced models. The 12-volt battery becomes the mainstream power supply.

1954

◄The Nash-Kelvinator Company and Hudson Motors unite to form the American Motors Corporation (AMC).
◄The Studebaker Company and Packard Motors unite to form the Studebaker-Packard Corporation.

1955

◄The American automotive industry enjoys the best business in its history, with production volume exceeding 9,200,000 vehicles (7,950,000 private passenger vehicles).
◄Kaiser retreats from the passenger vehicle market and goes strictly into four-wheel drive Jeep production.
◄American Motors installs 8-cylinder engines into its Ambassador series.

1956

◄ The Ford Company goes public and begins to sell its stock. About a million shares owned by the Ford Foundation are released to the market at a price of $64.50 per share.
◄ A new freeway law is promulgated, and the 41,000-mile interstate system is begun.
◄ The Studebaker-Packard Company decides to close its Packard plant, moving production of the Packard to the Studebaker factory.
◄ The forty-second national automobile show is held at the newly constructed New York Coliseum. For the first time in its history, the show is broadcast throughout the country on television, and about 21.6 million Americans tune in.

1957

◄ Oldsmobile celebrates its sixtieth anniversary.
◄ The 10 millionth Plymouth comes off the line.
◄ American Motors ceases production of the Nash and Hudson cars with their 1957 models.
◄ Ford introduces the Edsel.

1958

◄ Ford reaches the 50-million-vehicle milestone.
◄ Chrysler reaches the 25-million-vehicle milestone.
◄ GM celebrates its fiftieth anniversary.
◄ Studebaker-Packard ceases production of Packard cars altogether.
◄ Chrysler acquires 25 percent of the French corporation Simca.

1959

◄ Ford ceases production of the Edsel a mere three years after its debut in 1957. During this period, the number of registered owners in the U.S. domestic market totals only 106,000.

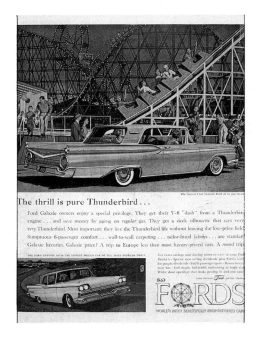

The thrill is pure Thunderbird...

Here's an economy car with a difference you'll like: room! Thirty miles per gallon. A sensible price. And inexpensive upkeep. These economy features make the Peugeot '403' an easy car to own. Just as important, it is a comfortable car to ride in. A family of 5 or 6 can travel for hours on its foam rubber-padded leatherette seats—and arrive refreshed! The Peugeot is highly maneuverable. Easy to park. And the price of $2175 (P.O.E., N.Y.) includes all this: sliding sunroof, whitewall or Michelin "X" tires, 4-speed synchromesh transmission, heater-defroster, padded dashboard, electric clock and reclining seats.

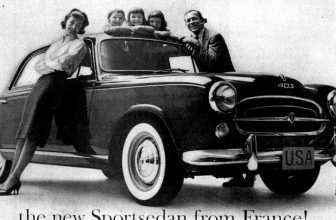

the new Sportsedan from France!
PEUGEOT
PRONOUNCED POO-JO

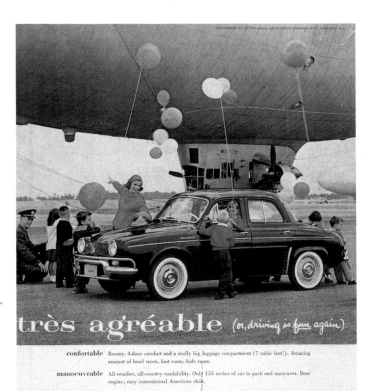

très agréable (or, driving is fun again)

confortable Roomy, 4-door comfort and a really big luggage compartment (7 cubic feet!). Amazing amount of head room, foot room, kids room.

manoeuvrable All-weather, all-country roadability. Only 155 inches of car to park and maneuver. Rear engine; easy conventional American shift.

formidable A pleasure to own and drive any way you look at it. Trim, elegant, Parisian styling; a whole palette of body colors to choose from with contrasting vinyl-and-fabric upholstery.

budget-able Only $1645 Port of Entry, N. Y. including these delightful economies: up to 40 mpg; a very high resale value; and over 500 coast-to-coast Service and Parts HQ. Fun from the word *allez!* See and try your Dauphine, today.

RENAULT Dauphine

MADE IN FRANCE. FOR ILLUSTRATED BROCHURE SEE YOUR LOCAL DEALER OR WRITE: RENAULT, INC., 405 PARK AVENUE, N. Y. 22, N. Y.

Small Is Beautiful

"Better than they like eating, Americans like to get into a full-sized V-8 car, its air-conditioner turned up, and cruise along the highway at top speed with the car radio blasting away. Small, foreign cars that look like movable toilets won't be acceptable to the American consumer." So believed the managers of U.S. automotive manufacturers like GM and Ford in the 1950s.

This, however, was merely the arrogance of Detroit.

As the American lifestyle changed, so did the public's taste in cars. In particular, middle-class, urban consumers readily switched to small, economical European cars. A rapid increase was also noted in the number of people who chose small European cars over American cars for their supplementary vehicle.

Year after year, the European cars steadily expanded their market share. In 1957 the number-one imported car was the Volkswagen, fondly called the Beetle. The second-ranking import was Renault, followed by British Ford, MG, Hillman, and Volvo.

Japanese cars like Toyota and Datsun appeared in the rankings only in the 1960s, especially in the latter half, some ten years after the above rankings.

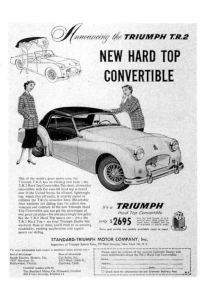

Announcing the **TRIUMPH T.R.2**

NEW HARD TOP CONVERTIBLE

It's a **TRIUMPH** Hard Top Convertible
only $2695

STANDARD-TRIUMPH MOTOR COMPANY, Inc.
Importers of Triumph Sports Cars, 99 Park Avenue, New York 16, N.Y.

25

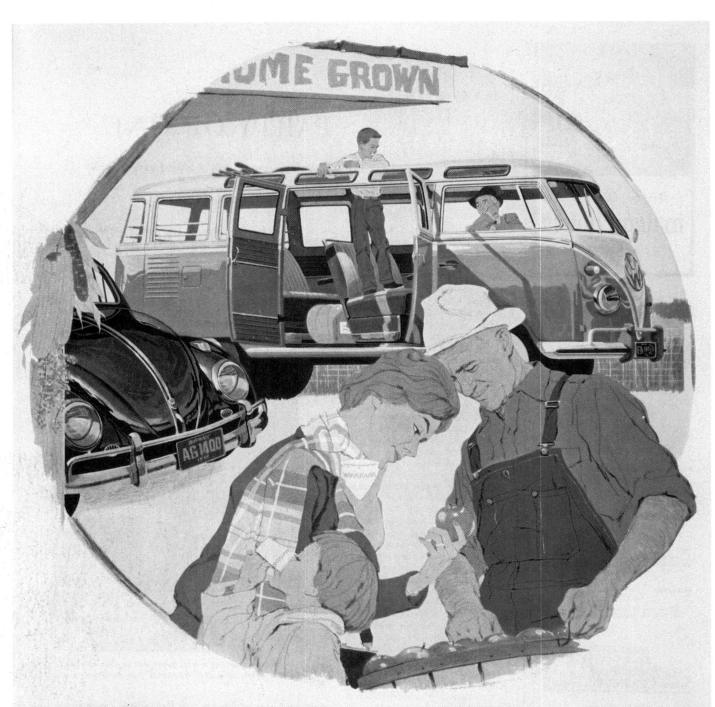

The full of sun, full of fun Station Wagon

A Volkswagen DeLuxe Station Wagon, to be sure! It's the growing American family's
pride and joy — roomy as can be — and carefree as the whole outdoors with sliding sun-roof, skylights and
big picture windows. And with all this fun . . . Volkswagen quality,
Volkswagen dependability, Volkswagen economy.

Famous VW Service and Genuine VW Spare Parts available in all 49 states

For free full-color
illustrated brochure, write
P. O. Box 2502, New York 17, N. Y.

VOLKSWAGEN

You'll be smart to be curious about...

MORRIS '1000'

ARRANGE TO TEST-DRIVE THE MORRIS '1000' TODAY!

New low price! Same great car! 2-door sedan, 4-door sedan, convertible and station wagon models available starting as low as $ **1495**

PORT OF ENTRY

Now, more than ever...your **biggest** small car buy!

Functional beauty. The design of the Citroen Automobile is an harmonious expression of its mechanical efficiency, and will never become outdated. Its lines are expressive of economy and practicality. ⚹ Over 90 mph and up to 34 mpg and... Air-Oil Suspension...creating a new definition of comfort, sensed exclusively in Citroen.

...in pursuit of happiness
...drive a Citroën!

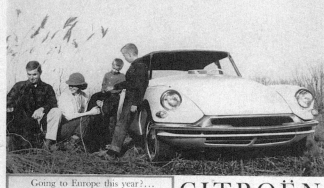

Going to Europe this year?...

A car is a must in Europe! Citroen has a car for every budget.
Order it here. Claim it there. Drive it there. Bring it...home! Or take advantage of the Direct Factory Repurchase Plans. For free booklet and early reservations write today to: Citroen Overseas Delivery Dept. #2

CITROËN
CARS CORPORATION

500 PARK AVENUE, NEW YORK 22, NEW YORK
8423 WILSHIRE BLVD., BEVERLY HILLS, CALIFORNIA

A nationwide network of factory-trained Dealers throughout the United States and Canada. Write for free Road Test Reports and illustrated brochure.

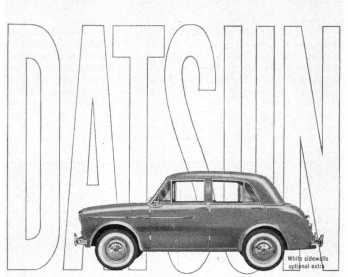

White sidewalls optional extra

DATSUN—The Foreign Car CLASSIC
Built to last for 20 years.
The only fine car combining weight **plus** economy.
$1616 poe. The outstanding import value.

The Datsun Motor Car weighs 2,035 pounds, offers up to 40 miles per gallon. Full width foam seats for 4 or 5 persons. Superb craftsmanship. Rugged 100 kilometer factory tests for each vehicle. At Franchised Dealers throughout America, or write your nearest Distributor.

D DATSUN/NISSAN MOTOR COMPANY, LTD./TOKYO, JAPAN/SINCE 1926

DATSUN

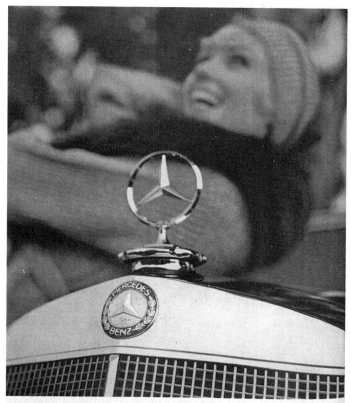

Character and quality: The inherent ingredients that have made Mercedes-Benz cars the automotive yardstick of excellence for over half a century. Meticulous attention to detail on the part of every craftsman and integrity of design in every model—sports car, sedan and convertible—provide each owner with a priceless gift: pride of ownership and delight in driving behind the symbol of the three-pointed star.

Mercedes-Benz cars include sedans, convertibles, and sports cars. Prices range from about $3,500 to $13,000. Ask your Mercedes-Benz dealer for a demonstration.

Mercedes-Benz Sales, Inc. (A Subsidiary of Studebaker-Packard Corporation)

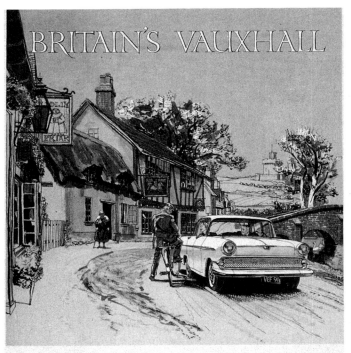

BRITAIN'S VAUXHALL

**This is the fine small car from England
sold and serviced by Pontiac dealers throughout America**

You'll like the Vauxhall for the same reasons the British do. It's compact, trim, taut and more often than not goes thirty-five miles on each gallon of gasoline. Yet nothing has been overlooked to give it the convenience Americans demand.

It seats five passengers comfortably. There are four good-size, easy-to-enter doors. The windshield is the wrap-around type, as is the rear window. There's ample trunk space. The gearshift is American style. And, most significantly, your Vauxhall can be readily serviced by authorized Pontiac dealers located in practically every village and hamlet throughout the States.

Built by General Motors in England, the Vauxhall is becoming an extremely popular import among Americans who want something distinctive in a small car.

See or call the Pontiac dealer nearest you and tell him you'd like to try out a Vauxhall for a day or so. It's quite an automobile.

Hillman prices start at $1639 P.O.E. Western states slightly higher. Full line includes Sedans and Station Wagons. Write for overseas delivery facts.

Hillmanship proves that the best things in life can cost $2099

Open up and let the sun shine in. Top adjusts to 3 positions. Precision engine gives up to 35 mpg. Room for 5. Full-size trunk for luggage. Test-drive it at your Hillman dealer's now.

ROOTES PRODUCTS: SUNBEAM · SINGER · HUMBER HILLMAN
Rootes Motors, Inc., 505 Park Ave., N.Y., N.Y. · 9830 W. Pico Blvd., L.A., Calif. · Rootes Motors (Canada) Ltd., Toronto, Montreal, Vancouver

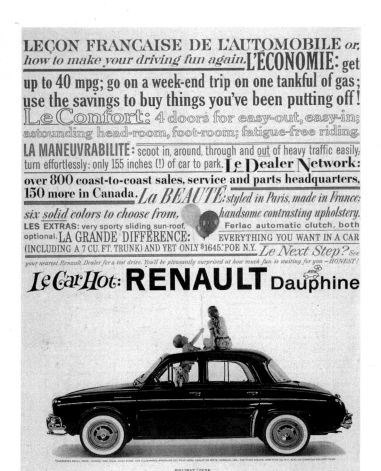

LEÇON FRANÇAISE DE L'AUTOMOBILE or, *how to make your driving fun again.* **L'ÉCONOMIE:** get up to 40 mpg; go on a week-end trip on one tankful of gas; use the savings to buy things you've been putting off! **Le Confort:** 4 doors for easy-out, easy-in; astounding head-room, foot-room; fatigue-free riding. **LA MANEUVRABILITE:** scoot in, around, through and out of heavy traffic easily; turn effortlessly; only 155 inches (!) of car to park. **Le Dealer Network:** over 800 coast-to-coast sales, service and parts headquarters, 150 more in Canada. *La BEAUTÉ:* styled in Paris, made in France; *six solid colors to choose from,* handsome contrasting upholstery. **LES EXTRAS:** very sporty sliding sun-roof. Ferlac automatic clutch, both optional. **LA GRANDE DIFFERENCE:** EVERYTHING YOU WANT IN A CAR (INCLUDING A 7 CU. FT. TRUNK) AND YET ONLY $1645 POE N.Y. *Le Next Step?* See *your nearest Renault Dealer for a test drive. You'll be pleasantly surprised at how much fun is waiting for you—HONEST!*

Le Car Hot: **RENAULT** Dauphine

HOLIDAY/JUNE

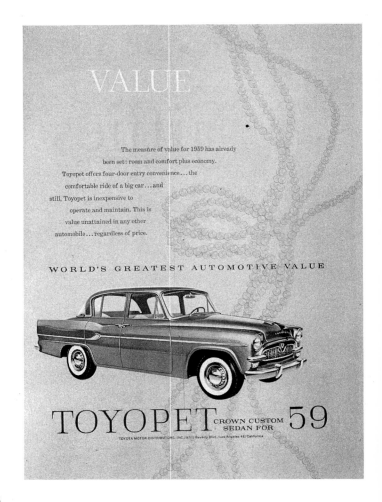

VALUE

The measure of value for 1959 has already been set: room and comfort plus economy. Toyopet offers four-door entry convenience...the comfortable ride of a big car...and still, Toyopet is inexpensive to operate and maintain. This is value unattained in any other automobile...regardless of price.

WORLD'S GREATEST AUTOMOTIVE VALUE

TOYOPET CROWN CUSTOM SEDAN FOR 59

TOYOTA MOTOR DISTRIBUTORS, INC., 3701 Beverly Blvd., Los Angeles 48, California

first

in Valve-in-Head performance with economy

Step out in a Chevrolet and enjoy *higher thrills* with *lower costs* every minute, month and mile you drive! You'll find owners are right when they say Chevrolet brings you the finest combination of thrills and thrift available today. For it's the only low-priced car powered by a *Valve-in-Head* Engine . . . trend-setter for the industry. And remember—Chevrolet offers a choice of *two* great Valve-in-Head engines at lowest cost!

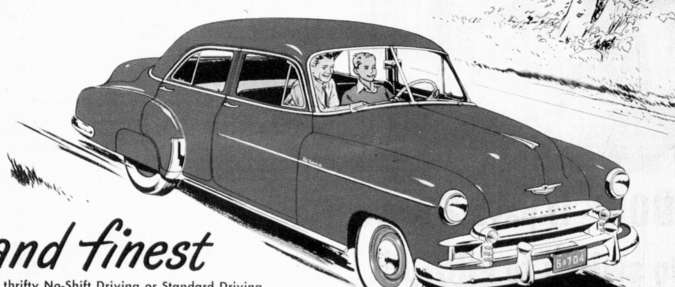

The Styleline De Luxe 4-Door Sedan

and finest

for thrifty No-Shift Driving or Standard Driving

CHEVROLET Chevrolet gives you the *finest* kind of *no-shift driving* at lowest cost, with the phenomenal Powerglide Automatic Transmission, teamed with a 105-h.p. Valve-in-Head Engine.* You get the finest kind of *standard driving* at lowest cost in a Chevrolet with the highly improved standard Valve-in-Head Engine and Silent Synchro-Mesh Transmission.

Combination of Powerglide Automatic Transmission and 105-h.p. Engine optional on De Luxe models at extra cost.

at lowest cost

with fine-car feature after fine-car feature at lowest prices

CHEVROLET Moreover, Chevrolet brings you many other exclusive fine-car features, including Body by Fisher for topmost beauty, comfort and safety; Center-Point Steering and the Unitized Knee-Action Ride for maximum steering-ease and riding-ease; and Curved Windshield with Panoramic Visibility and Proved Certi-Safe Hydraulic Brakes for greatest safety protection. See and drive Chevrolet, and you'll agree, it's *first and finest at lowest cost!*

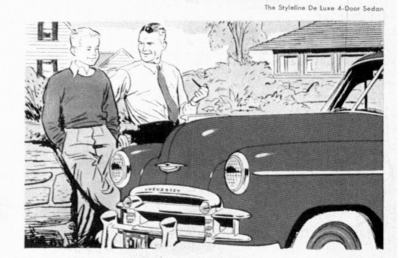

AMERICA'S BEST SELLER . . . AMERICA'S BEST BUY
CHEVROLET MOTOR DIVISION, *General Motors Corporation*, DETROIT 2, MICHIGAN

'50 Chevrolet

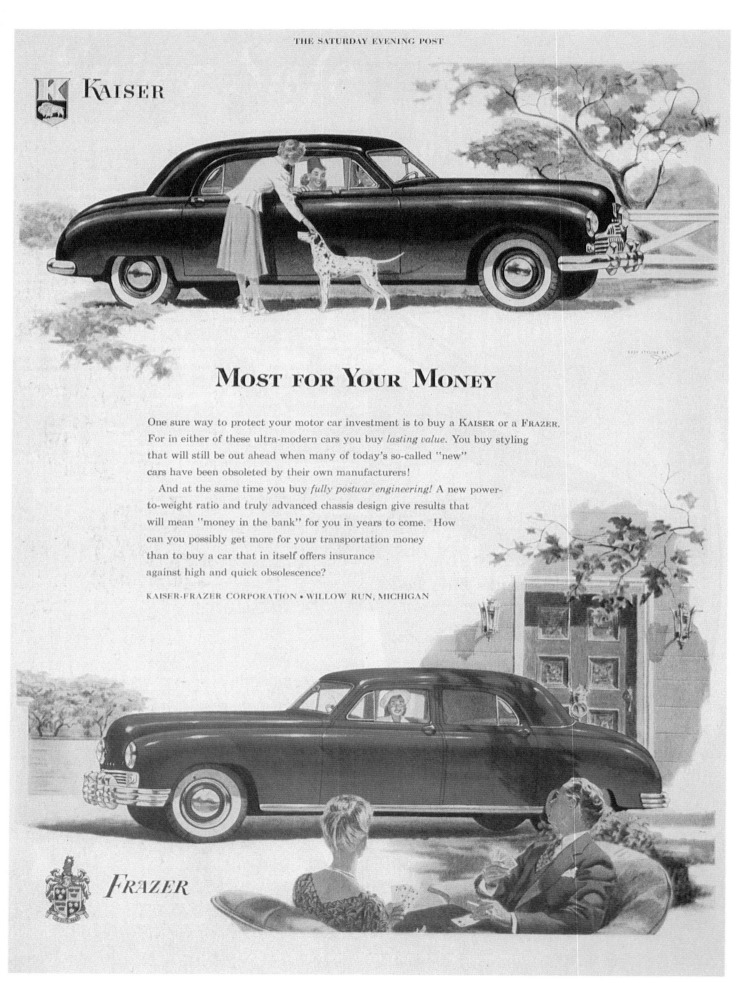

KAISER

MOST FOR YOUR MONEY

One sure way to protect your motor car investment is to buy a KAISER or a FRAZER. For in either of these ultra-modern cars you buy *lasting value*. You buy styling that will still be out ahead when many of today's so-called "new" cars have been obsoleted by their own manufacturers!

And at the same time you buy *fully postwar engineering!* A new power-to-weight ratio and truly advanced chassis design give results that will mean "money in the bank" for you in years to come. How can you possibly get more for your transportation money than to buy a car that in itself offers insurance against high and quick obsolescence?

KAISER-FRAZER CORPORATION • WILLOW RUN, MICHIGAN

FRAZER

'48 Kaiser—Frazer

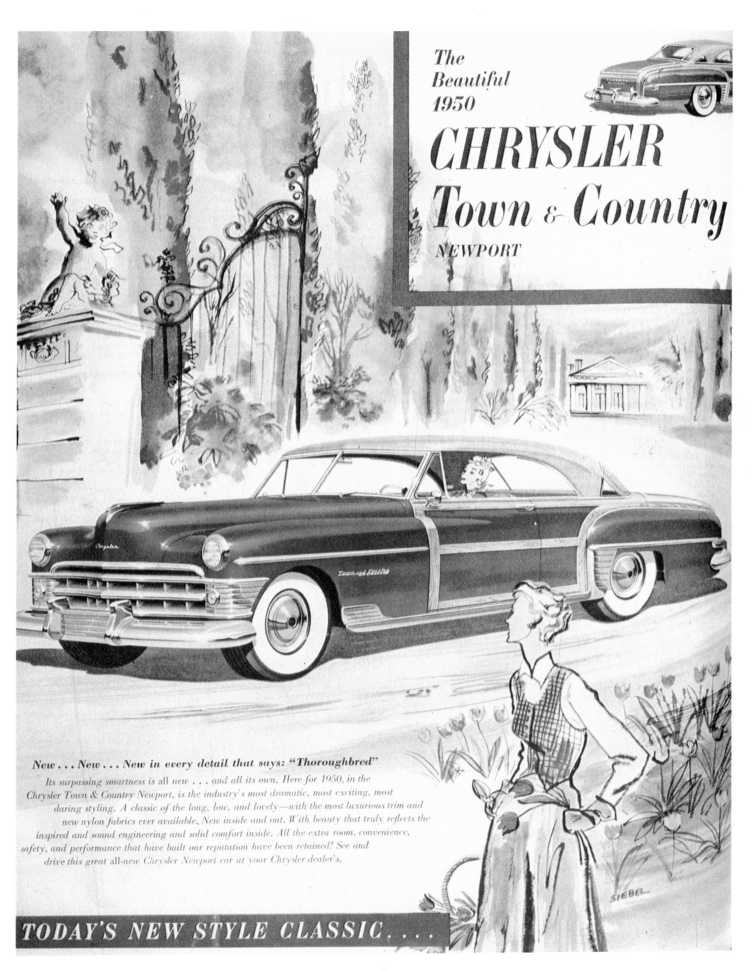

The
Beautiful
1950

CHRYSLER

Town & Country

NEWPORT

New . . . New . . . New in every detail that says: "Thoroughbred"

Its surpassing smartness is all new . . . and all its own. Here for 1950, in the
Chrysler Town & Country Newport, is the industry's most dramatic, most exciting, most
daring styling. A classic of the long, low, and lovely—with the most luxurious trim and
new nylon fabrics ever available. New inside and out. With beauty that truly reflects the
inspired and sound engineering and solid comfort inside. All the extra room, convenience,
safety, and performance that have built our reputation have been retained! See and
drive this great all-new Chrysler Newport car at your Chrysler dealer's.

SIEBEL

TODAY'S NEW STYLE CLASSIC

'50 Chrysler Town & Country

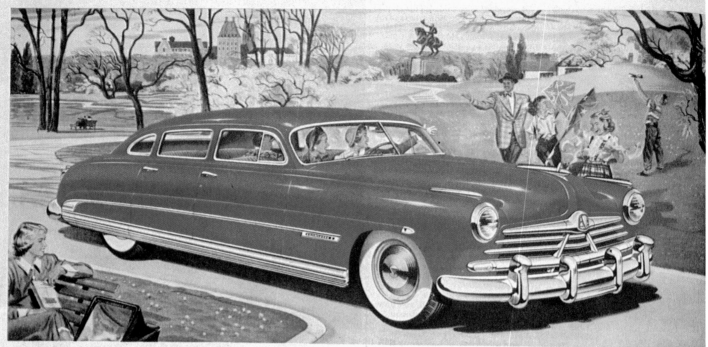

Available with New Super-matic Drive† — Only Cars with "Step-Down" Design

Most Room! Best Ride! Safest!
"The New Step-Down Ride"

Available only in Hudson because Hudson is built differently

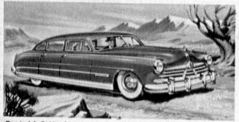

Best ride? Yes! Free-flowing, low-built design quickly tells you that the New Hudson has the lowest center of gravity in any American automobile—and this right along with full road clearance! As a result, you know instinctively that this thrilling motor car hugs the road more tenaciously than any other automobile, and is therefore America's best-riding and safest car! Hudson dealers everywhere invite you to try "The New Step-Down Ride" and experience these wonders firsthand!

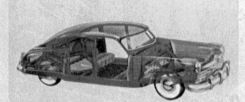

Safest? Absolutely! Hudson's low center of gravity makes it a steady, sure-handling car. And for even greater safety, Hudson's Monobilt body-and-frame*, an all-welded, all-steel single unit of construction, rides you down within a base frame (shown in red above) with box-section steel girders completely encircling and protecting the passenger compartment—even outside the rear wheels!

*Trade-mark and patents pending.

MOST room in any car at any price, and with all this you get, in Hudson, America's best-riding, safest car!

Your very first glance inside the New Hudson shows you that the seats are positioned not only ahead of the rear axle, but entirely ahead of the rear wheels.

This permits full use of body width, and as a result, the sensational New Hudson of normal exterior width brings you seat cushions that are *up to 12 inches wider* than those in cars of greater outside dimensions! Even the door controls and arm rests in Hudson are set in recessed door panels so that they do not interfere with passenger room.

You'll see, too, that Hudson's exclusive "step-down" design, with its recessed floor, brings vital space into the passenger compartment, instead of wasting it under the floor and between frame members as is the case in all other cars!

This provides, in Hudson, more head room than in any mass-produced car built today.

But Hudson's fabulous room is only part of the story. We invite you to read, to the left, why "The New Step-Down Ride" is America's best and safest ride—then see your Hudson dealer—soon! Hudson Motor Car Company, Detroit 14.

HUDSON

NOW . . . 3 GREAT SERIES

Lower-Priced Pacemaker Famous Super Custom Commodore

MOST ROOM! . . . BEST RIDE! . . . SAFEST!

ONLY HUDSON, THE CAR WITH "THE NEW STEP-DOWN RIDE", BRINGS YOU THESE ADDITIONAL FEATURES . . . Chrome-alloy motor blocks which minimize wear and reduce upkeep costs • Triple-Safe Brakes—finest hydraulic system with reserve mechanical system on same pedal, plus finger-tip-release parking brake • Fluid-Cushioned Clutch • Wide-arc vision with Curved Full-View windshield and rear window • Weather-Control†—Hudson's heater-conditioned-air system • Super-Cushion tires • Safety-Type wide rims • Center-Point Steering and more than 20 other high-performance, long-life features that help make "step-down" designed Hudsons leaders in resale value, coast to coast, as is shown by Official Used Car Guide Books! †Optional at extra cost.

'50 Hudson

Shiftless.... *and very proud of it!*

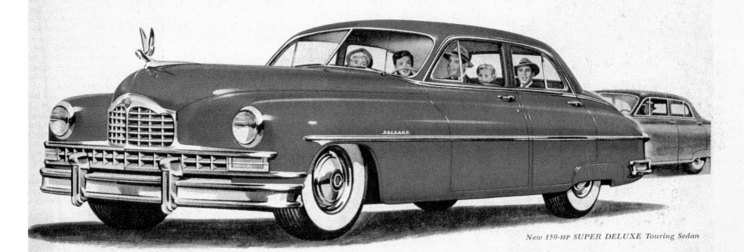

New 150-HP SUPER DELUXE Touring Sedan

There's never been anything like

Packard Ultramatic Drive

You'll have no clutch pedal to push . . . no gears to shift. And those are just the *first* two points to remember about Packard Ultramatic Drive!

You'll never be annoyed by jerking or clunking, or "racing engine sensation". . . never bothered by gas-wasting slippage at cruising speeds . . . never "out-smarted" by complicated automatic controls.

In *every* phase of motoring, Packard Ultramatic Drive brings you wonderful new driving ease . . . be-cause it begins with new basic *principles*.

Born of a 16-year Packard development program—backed by $7,000,000 in new manufacturing facilities —Packard Ultramatic Drive is now available, at extra cost, on an increasing number of models.

Don't miss a demonstration of this amazing new drive! Once you've heard the whole exciting story, you'll know why impartial technical observers call it "the *last word* in automatic, no-shift control!"

ASK THE MAN WHO OWNS ONE

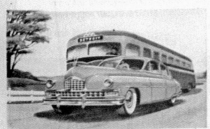
More responsive: No slippage at cruising speeds. No lag, waiting for gears to shift. For in-stant bursts of acceleration—just *"tramp down!"*

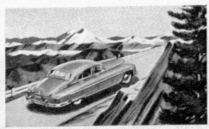
More positive: No over-heating of the drive mechanism during long climbs. Smooth, grad-ual engine braking on down-grades.

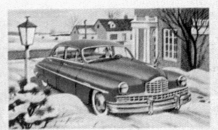
More flexible: Choice of *acceleration* or *cruis-ing*, in both low and high range: Easy change from Forward to Reverse without clashing.

'50 Packard

FOR 1950—IT'S THE NASH AIRFLYTE!

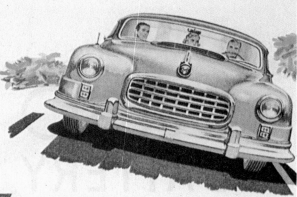

Now—Hydra-Matic Drive! Yes, in the Nash Ambassador Airflyte you can have the best of all automatic transmissions—Hydra-Matic Drive. And with exclusive Nash Selecto-Lift Starting you just lift a lever—and *go*. The clutch is gone. Your hands do nothing but steer. Your left foot does nothing at all!

20% Less Wind-Drag! Like invisible wings, the air-splitting Airflyte design speeds you along with 20% less wind-drag than the average car of current design—proved by scientific wind-tunnel test. That means less fuel cost... less wind noise... less fatigue... greater stability.

Slip into the seat of a 1950 Nash, and watch two words—*Airflyte Construction*—loom big in your life.

Different? You sit inside a twist-proof, rattle-proof, all-welded fuselage that's *twice* as rigid—and so spacious the seats can become Twin Beds.

It slips through the air with 20% less wind-drag—and with new Super-Compression power, *you've got performance!*

Rough road? Feel those super-soft coil springs soak up shock like a sponge soaks water. Airflyte Construction makes this a rock-solid road-hugger. Raw weather? Just set that Nash "Weather Eye."

Gas gauge stuck at "full"? Man, you're new around here! A Nash Statesman gets more than 25 miles to a gallon at average highway speed. See two great 1950 Airflyte series at your Nash dealer's now—drive the new Ambassador with Hydra-Matic!

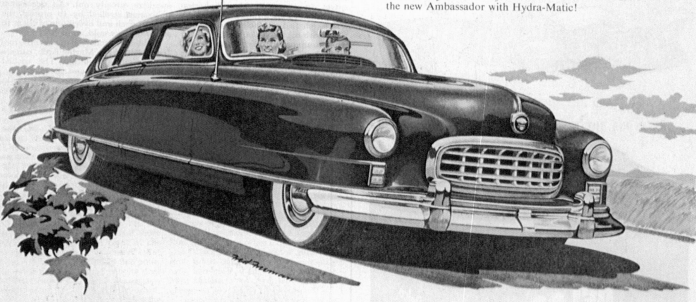

ONE SINGLE WELDED UNIT STRONGER —WEIGHS LESS

Nash is the World's only car with Airflyte Construction. The entire frame and body, floor, roof and rear fenders are built as a single welded unit... twice as rigid as ordinary construction... squeak-free, rattle-proof. Makes possible new safety, economy and riding comfort.

Nash AIRFLYTE

The Statesman · The Ambassador

GREAT CARS SINCE 1902

Nash Motors, Division Nash-Kelvinator Corporation, Detroit, Mich.

You've got to <u>drive</u> it to believe it!

You can always tell an Oldsmobile "88"—not just by the numerals on the rear fender—but also by the way it *goes!* The first time you see that sleek Futuramic hood sweep ahead of the field, you get a hint of that "Rocket" Engine power. But to appreciate an "88," you've got to *try* it! Then—and only then—can you feel for yourself that swift-surging "Rocket" response . . . so smoothly delivered by Hydra-Matic Drive*. Only then will you experience the maneuverability that comes with the "88's" compact Body by Fisher. And only then will you know the unique "88" sensation—that soaring, air-borne ease of travel! You've got to *drive* it to *believe* it—and your Oldsmobile dealer invites you to do so *soon!* Phone him—make a date with the "88"—discover the most thrilling "New Thrill" of all!

"88"

LOWEST-PRICED CAR WITH "ROCKET" ENGINE

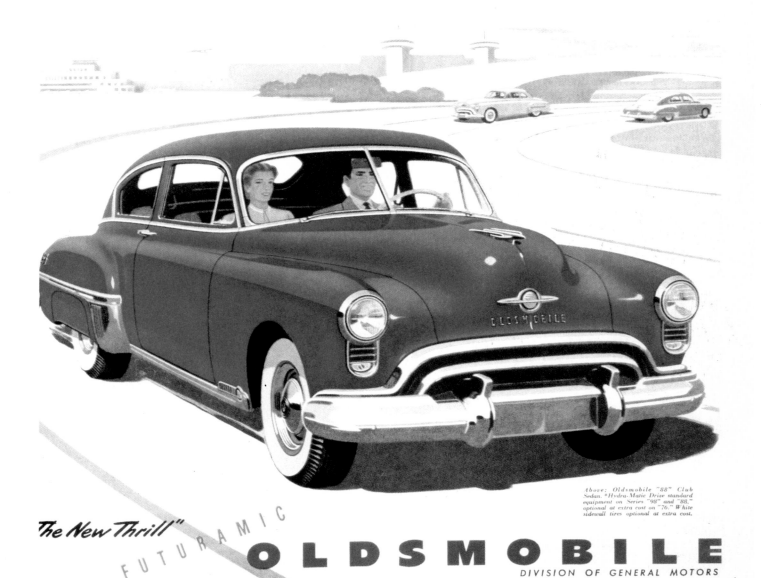

*Above: Oldsmobile "88" Club Sedan. *Hydra-Matic Drive standard equipment on Series "98" and "88," optional at extra cost on "76." White sidewall tires optional at extra cost.*

The New Thrill

FUTURAMIC **OLDSMOBILE**

DIVISION OF GENERAL MOTORS

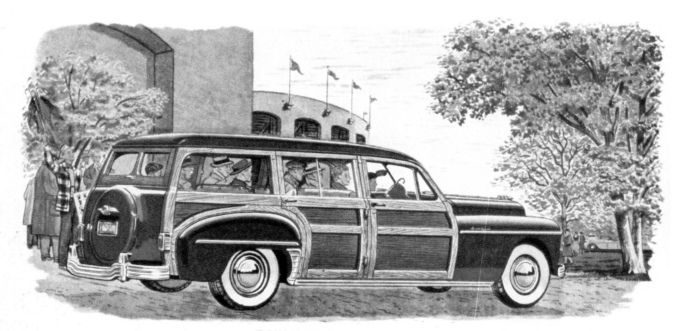

IT GOES TO THE STADIUM ... FOR EIGHT! This great new Plymouth Station Wagon sets new standards for beauty, utility and long life. Comfortably seats eight full-sized passengers. Both rear seats quickly and easily removed for maximum loading space. Handsome, easy-to-clean vinyl plastic seats and seat backs. Natural-finish bonded plywood body panels with long-life finish on all-wood surfaces. New body construction—new steel floor and top—make this the safest, most rugged Plymouth Station Wagon ever built—with Plymouth engineering advantages throughout. Before you buy—compare!

PLYMOUTH

THE CAR THAT LIKES TO BE COMPARED

WHAT SPORT ... TO DRIVE IT! This beautiful new Plymouth Convertible Club Coupe features distinguished styling and all-weather comfort. Electric-hydraulic mechanism silently raises or lowers new, smartly styled top in about fifteen seconds. Roomy rear seat with plenty of leg room. More powerful 97-horsepower engine with seven-to-one compression ratio. Ignition-Key Starting with electric automatic choke. The famous Plymouth Air Pillow Ride is now smoother than ever before! See your nearby Plymouth dealer now.

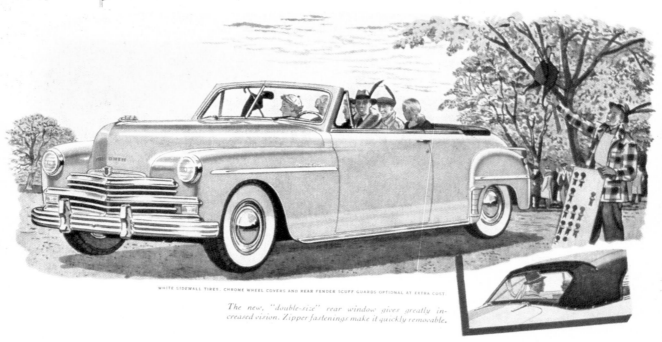

WHITE SIDEWALL TIRES, CHROME WHEEL COVERS AND REAR FENDER SCUFF GUARDS OPTIONAL AT EXTRA COST.

The new, "double-size" rear window gives greatly increased vision. Zipper fastenings make it quickly removable.

'49 Plymouth

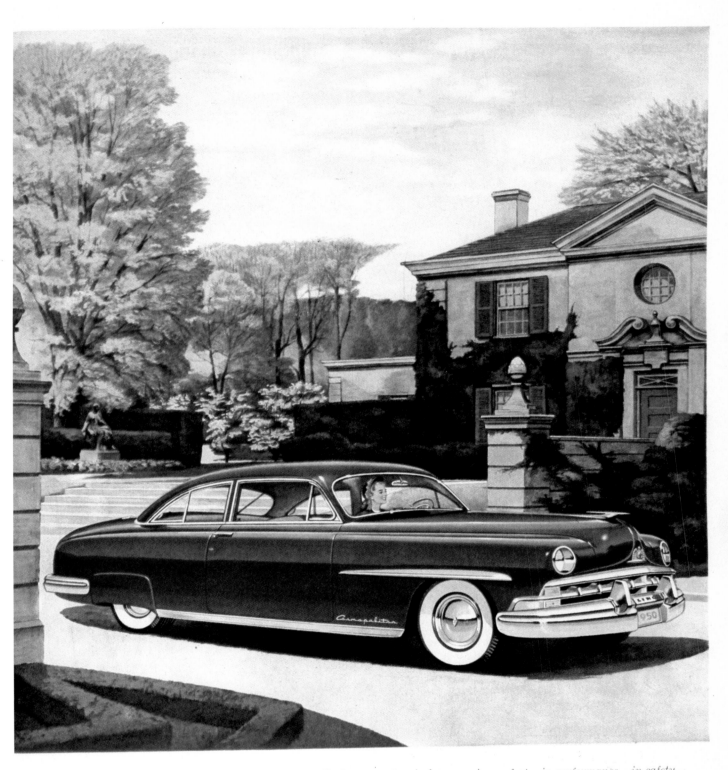

As outstanding as it is in all other respects...in luxury...in comfort...in performance...in safety...
and in prestige...distinction is the chief distinction of the 1950 Lincoln Cosmopolitan...
and you may drive it everywhere with pride in that assurance. Lincoln Division of Ford Motor Company.

Improved HYDRA-MATIC transmission optional at extra cost

Lincoln...Nothing could be finer

'50 Lincoln

41

"You can hardly hear it!"

"It's beautiful"

Actually more than a quarter-million families are *two-*Ford families! And many of them have two big *1950* Fords. They love the extra handiness of two cars! They're sold on the extra economy of Ford ownership.

They've found that "Power Dome" combustion chambers in both the 100 h.p. V-8 and the 95 h.p. Six give high compression performance on regular gas—a saving that amounts to real money! And they've found that Fords are low in first cost and high in resale value!

Now Thousands own <u>two</u> fine cars...

"Plenty of room for everything"

"Drives like a dream"

"Wide, easy opening rear deck"

and they're both '50 FORDS

Two smart travelling companions are the Ford Tudor Sedan and Ford Station Wagon! Both have styling that merited the Fashion Academy's Gold Medal Award.

The 35% easier-acting "King-Size" Brakes, the famous Ford "Lifeguard" Body—both cars have these Ford quality features and many more! "Test Drive" a Ford at your Dealer's today—the car you now own may well provide a down payment on two '50 Fords!

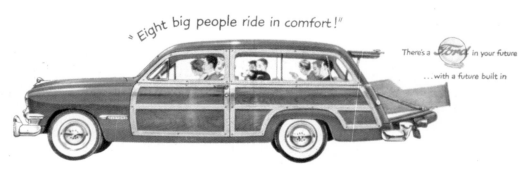

"Eight big people ride in comfort!"

There's a *Ford* in your future

...with a future built in

HOLIDAY / JUNE

'50 Ford

42

THIS CAR IS BUILT TO STAY NEW

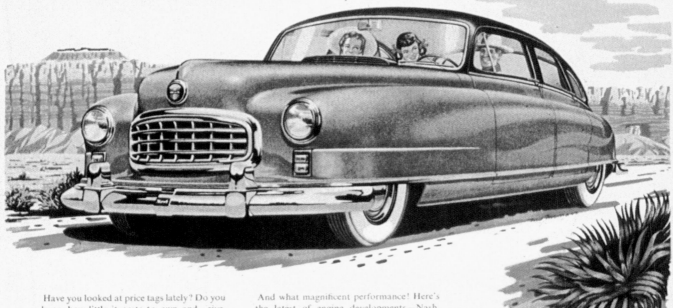

Have you looked at price tags lately? Do you know how little it costs to own and drive the most modern of America's fine cars?

Here are safety—comfort—economy and *long life* you will find *only* in Nash, the car of Airflyte Construction.

In beauty alone it is so efficient that you speed along with 20.7% less air drag than the average of all other cars tested. Drive it. Hear and feel the difference.

More Miles per Gallon

Then compare economy. These are *big* cars, with utmost room—but Airflyte Construction means better than 25 miles to the gallon at average highway speed in the Nash Statesman.

And what magnificent performance! Here's the latest of engine developments—Nash high-compression power on *regular* gasoline!

Check further. You'll find no other car offers a Weather Eye Conditioned Air System . . . or Twin Beds . . . or the Airliner Reclining Seat . . . or the riding smoothness of Nash.

And Hydra-Matic Drive!

In the 1950 Nash Ambassador you may have Hydra-Matic drive, with Nash exclusive Selecto-Lift Starting—nothing to do but lift a lever and *go!*

Yes—compare Nash with *any* car at *any* price. Drive the car that's built to *stay* new. Let your Nash dealer show you the many features which assure you better motoring today, higher resale value tomorrow.

STAYS NEW YEARS LONGER

Airflyte Construction, in Nash alone. The entire frame and body, floor, roof, pillars, are built as a single, rigid, welded unit—squeak-free, rattle-proof. Twice as rigid as ordinary construction, it gives new economy, new safety, makes possible a softer, smoother ride—stays new years longer, adds to resale value.

Nash AIRFLYTE

The Statesman · The Ambassador

Great Cars Since 1902

There's Much of Tomorrow In All Nash Does Today

Nash Motors, Division Nash-Kelvinator Corporation, Detroit, Mich.

'50 Nash

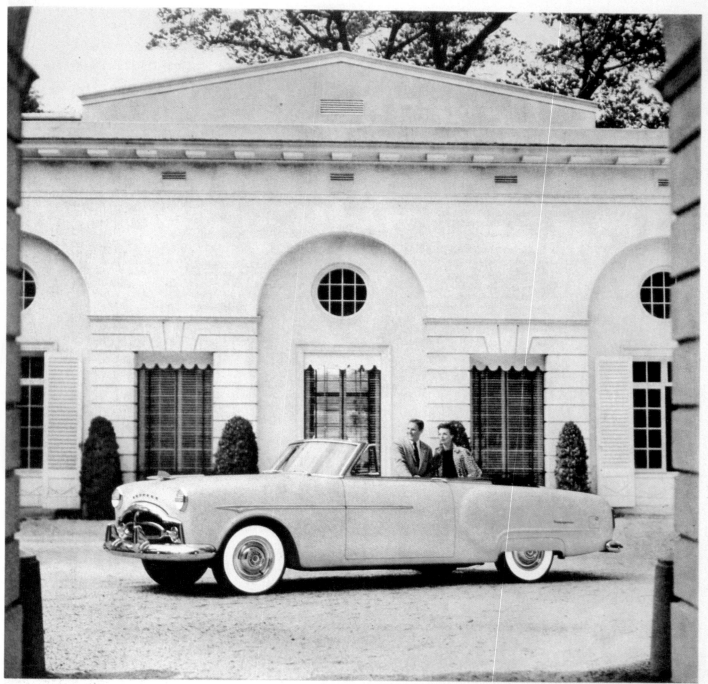

New 1951 Packard Convertible—one of nine all-new models

Pride of Possession is Standard Equipment

How can we put a price tag on your neighbors' look of envy . . . or on your own feeling of well-being . . . as you drive your new 1951 Packard home for the first time?

We can't, of course. So—*Pride of Possession is Standard Equipment*. Like the exclusiveness of Packard beauty—and the years-ahead superiority of Packard engineering—you can't buy a new 1951 Packard without it. And you never can match it—no matter how much you may be willing to pay—in *any other car!*

It's more than a car...it's a

PACKARD

ASK THE MAN WHO OWNS ONE

'51 Packard

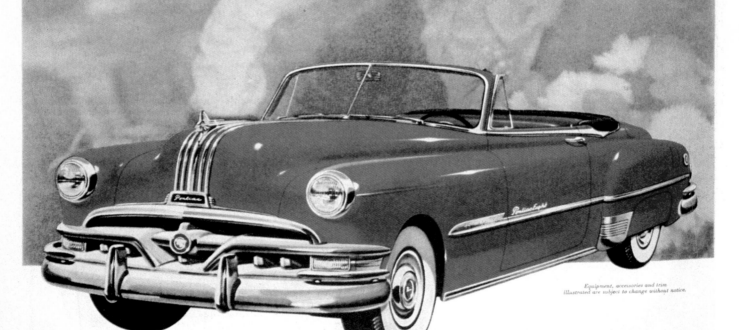
'51 Pontiac

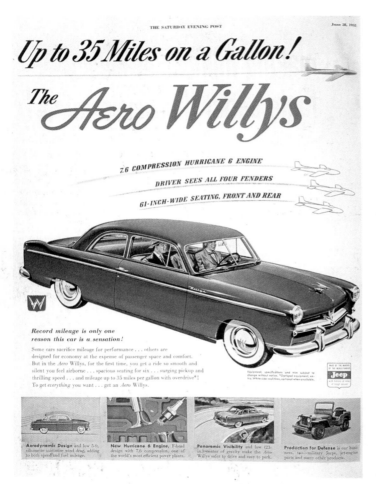

Up to 35 Miles on a Gallon!

The *Aero Willys*

7.6 COMPRESSION HURRICANE 6 ENGINE

DRIVER SEES ALL FOUR FENDERS

61-INCH-WIDE SEATING, FRONT AND REAR

Record mileage is only one reason this car is a sensation!

Some cars sacrifice mileage for performance . . . others are designed for economy at the expense of passenger space and comfort. But in the *Aero Willys*, for the first time, you get a ride so smooth and silent you feel airborne . . . spacious seating for six . . . surging pickup and thrilling speed . . . and mileage up to 35 miles per gallon with overdrive*! To get *everything* you want . . . get an *Aero* Willys.

Jeep

Aerodynamic Design and low 5-ft. silhouette minimize wind-drag, adding to both speed and fuel mileage.

New Hurricane 6 Engine, F-head design with 7.6 compression, one of the world's most efficient power plants.

Panoramic Visibility and low 123-in.-center of gravity make the Aero Willys safer to drive and easy to park.

Production for Defense is our business, too—military Jeeps, jet-engine parts and many other products.

'52 Aero Willys

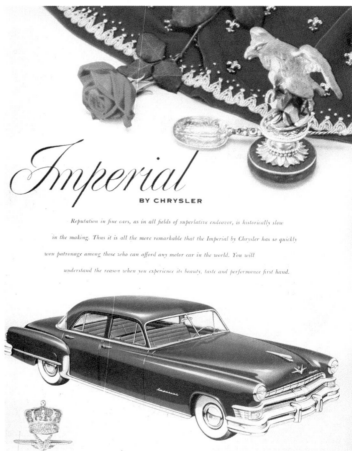

Imperial

BY CHRYSLER

Reputation in fine cars, as in all fields of superlative endeavor, is historically slow in the making. Thus it is all the more remarkable that the Imperial by Chrysler has so quickly won patronage among those who can afford any motor car in the world. You will understand the reason when you experience its beauty, taste and performance first hand.

The Finest Car America Has Yet Produced!

'52 Imperial

Stretch Out and See

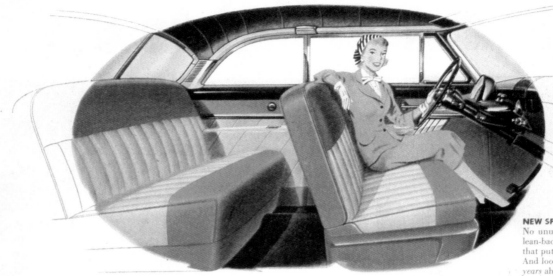

NEW SPACE-PLANNED DESIGN—
No unused space—this is the new
lean-back-and-take-it-easy Mercury
that puts every inch of car to work.
And looks? "Forerunner" styling is
years ahead.

Why It Challenges Them All

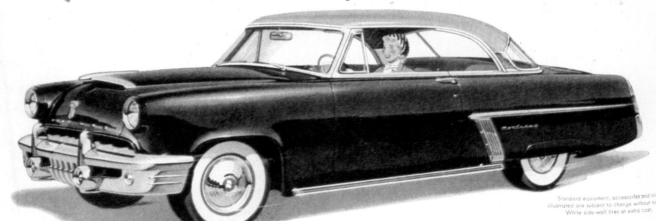

Standard equipment, accessories and trim
illustrated are subject to change without notice.
White side-wall tires at extra cost.

NEW SEA-TINT* GLASS reduces
heat, glare, and eyestrain. New
larger windows permit safety-sure
visibility all around. *Every* view
proves that Mercury is new—in
looks, in power, in extra value.

WE BUILT A NEW CAR and made this challenge: Match
Mercury *if you can.* Now we know we've got the
sweetest thing on wheels since the ladies began to drive.

For all America is falling in love with a car.

No wonder. It's big and beautiful, inside, outside, and
all over. With a host of Future Features—Forerunner
styling, Jet-scoop hood, suspension-mounted brake pedal,
Interceptor instrument panel, higher horsepower V-8
engine—the new Mercury is the most challenging car
that ever came down the *American Road*

See it, drive it. You'll fall in love, too. And with
Mercury's famous economy—*proved* in official tests—
this is a love affair you can afford.

MERCURY DIVISION · FORD MOTOR COMPANY

The New 1952
MERCURY
WITH MERC-O-MATIC DRIVE

3-WAY CHOICE—Mercury presents three dependable, performance-
proved drives: silent-ease, standard transmission; thrifty Touch-O-
Matic Overdrive,* and Merc-O-Matic,* greatest of all automatic drives.
Optional at extra cost

'52 Mercury

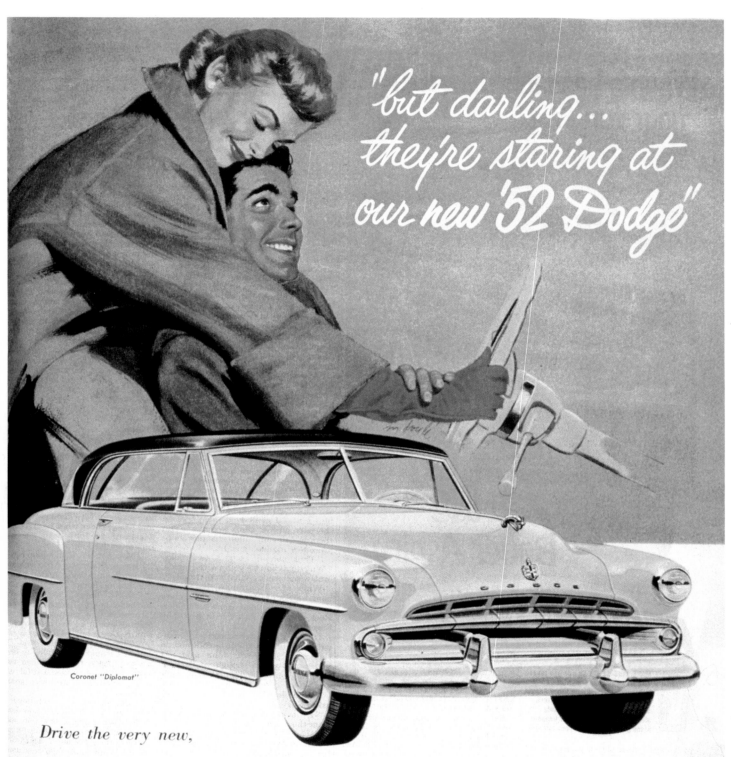

"but darling...
they're staring at
our new '52 Dodge"

Coronet "Diplomat"

Drive the very new,

very beautiful '52 Dodge

Enjoy greater all 'round visibility, smoother riding, extra roominess,
the pride and satisfaction of having spent your money wisely and well.

Big, new, dependable '52 **DODGE**

Specifications and equipment subject to change without notice.

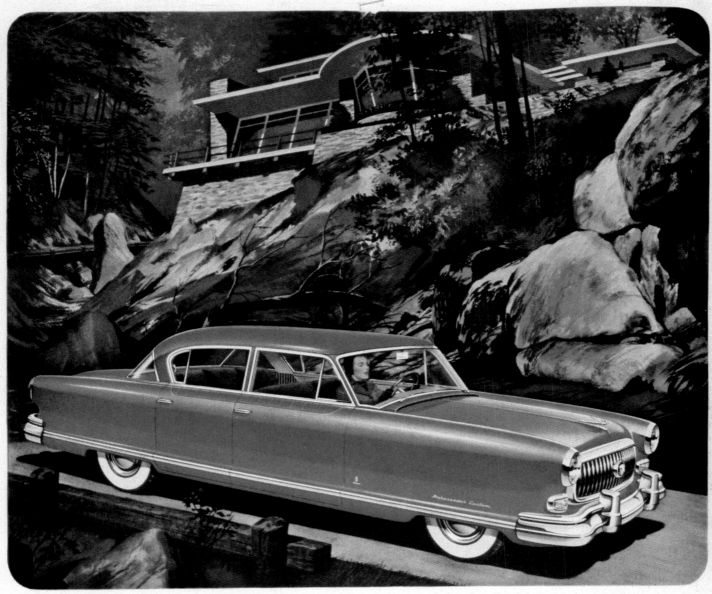

This 1952 Nash Ambassador is upholstered in Mediterranean Blue needle point and striped homespun. Reclining Seats, Twin Beds, Hood Ornament, glare-free tinted Solex glass and White Sidewalls optional extras. Your choice of three transmissions including Automatic Overdrive and new Dual-Range Hydra-Matic, at extra cost.

THERE'S A NEW "WHO'S WHO" OF THE HIGHWAY

YOU ARE NOT ALONE when you admire the picture above.

Because never before has any new car won such instant acclaim as the Nash Golden Air-flyte—*already* the new choice of thousands of distinguished Americans!

Here you see beauty that is *entirely new* . . . the swift, clean, continental styling of Pinin Farina, world's most famous custom designer.

Look inside. You'll find the widest seats, the greatest Eye-Level visibility and the most luxurious interior ever built into one car! You'll enjoy *double* Reclining Seats, with new Twin Bed arrangements . . . and thrill to a new view

of the road over the low, racy hood and distinctive Road-Guide Fenders!

Performance? Who could ask for more than a Super Jetfire engine even more powerful than the Nash Jetfire that set last year's stock-car speed record! Riding Ease? There's the unmatched magic of new Airflex suspension and safer, rattle-free Airflyte Construction!

Yes, there's a new standard of fine-car value on the highway today—a new "Who's Who". See your Nash dealer and learn how easily your golden dreams can come true!

TV Fun—*Watch Paul Whiteman's TV Teen Club. See your paper for time and station.*

Nash Motors, Division Nash-Kelvinator Corp., Detroit, Michigan

AMBASSADOR · STATESMAN · RAMBLER · THE FINEST OF OUR FIFTY YEARS

'52 Nash

53

Handsome and handy is the new Ford Country Sedan! Use it to tote 8 people in style or a half ton of freight! The back seat lifts right out, the center seat folds flush with the floor! Powered by 110-h.p. Strato-Star V-8. Fordomatic or Overdrive if you choose.

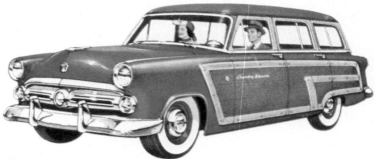

We call this 4-door beauty the Country Squire. You'll call it wonderful. Has all the new Country Sedan features . . . *plus* real maple or birch trim, framing mahogany-finished steel panels.

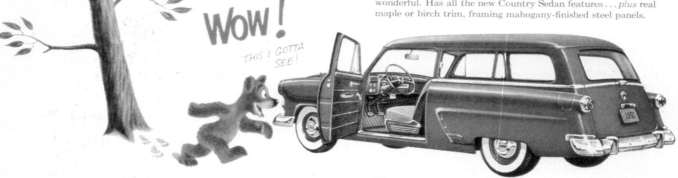

What a car—what a value! It's the 2-door Ranch Wagon . . . the lowest priced station wagon in its field . . . with a choice of 110-h.p. Strato-Star V-8 or 101-h.p. Mileage Maker Six.

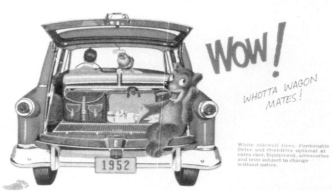

White sidewall tires. Fordomatic Drive and Overdrive optional at extra cost. Equipment, accessories and trim subject to change without notice.

Whichever Ford station wagon you choose you're hitched to a star with more "can do" than any other in the low-price field!

The greatest line of station wagons in the industry

WOWING 'EM EVERYWHERE! '52 FORD

You can pay more but you can't buy better!

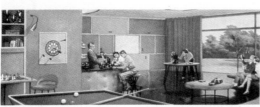

LIVABLE COMFORT OF A NEW-DAY PLAYROOM

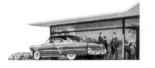

THE LIVELY ACTION OF TODAY'S SPORTSMEN

LINCOLN

lets you take modern living with you

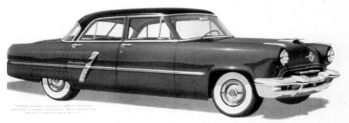

The **ACTION CAR** FOR *Active Americans*

New 140-h.p. Red Ram V-8, most efficient auto engine design in America.

New sleek, trim Beauty-Action Styling, with distinctive Jet Air-Flow hood.

New Gyro-Torque Drive with flash-action "Scat" gear for safer passing.

New colors and combinations...in lasting enamel that keeps its lustre.

New road-hugging, curve-holding ride, with new "Stabilizer" suspension.

New Travel-Lounge comfort with more hip-room, head-room and elbow-room.

New "Pilot View" curved windshield and wide wrap-around rear window.

New "Cargo Carrier" rear deck has up to 11 cubic feet more carrying capacity.

New steering ease, with controls *centered* between the two front wheels.

Announcing the

New—*All New* '53 Dodge

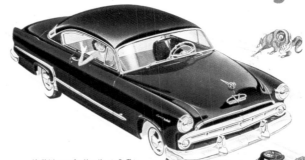

You'll Want to Get Your Hands On This

Power Packed Beauty

On Display Now ! Visit Your Nearest Dodge Dealer and Thrill to a 'Road Test' Ride

Sensational New
140 Horsepower RED RAM V-8 ENGINE !

Packs more power punch per cubic inch displacement... delivers a full 140-h.p. on "regular" gasoline. Brings you the triple power advantages of hemispherical combustion chamber... short stroke design... high-lift lateral valves. More fuel energy goes into *power*, less is wasted on heat, friction. Most efficient engine design in any American car!

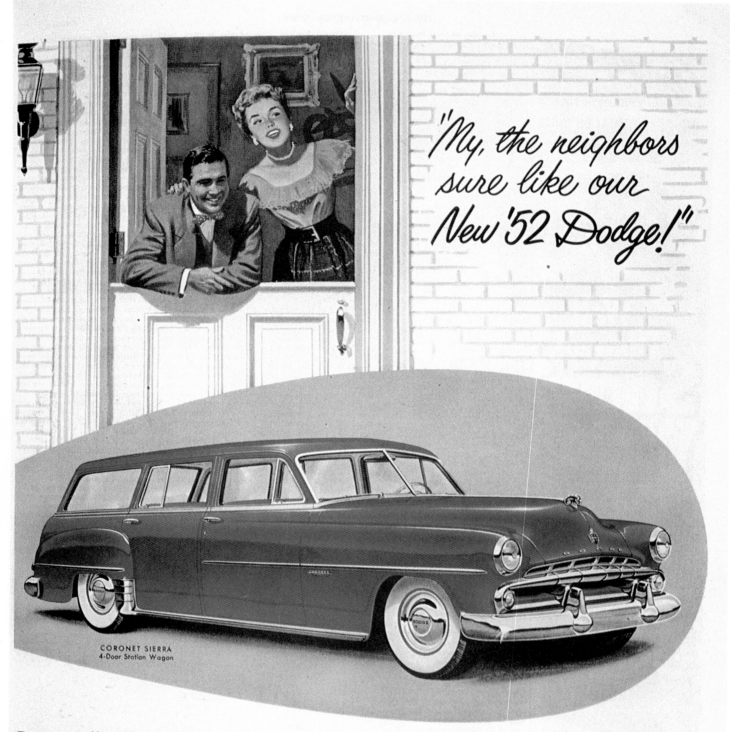

"My, the neighbors sure like our New '52 Dodge!"

CORONET SIERRA
4-Door Station Wagon

Let the "Show Down" Way show you why Dodge is so popular

This smart, new Dodge wins admirers with its looks . . . wins hearts with its dependable day-in, day-out performance. You get modern styling—advanced engineering that protects your investment for years ahead. Among its many exciting features is the amazing Dodge Oriflow Ride that makes every mile you travel boulevard-smooth.

And if you think this is just sales talk—your Dodge dealer can give you *proof!* Before you buy a car in *any* price class, ask him for a free copy of the "Show Down" Plan. It lets you compare Dodge feature by feature against other cars for greater driving ease, comfort and safety . . . greater value. Once you've made this comparison test, we're sure you'll see why "You could pay hundreds of dollars more and still not get all Dodge gives you!"

Specifications and Equipment Subject to Change Without Notice

Big, new, dependable '52 **DODGE**

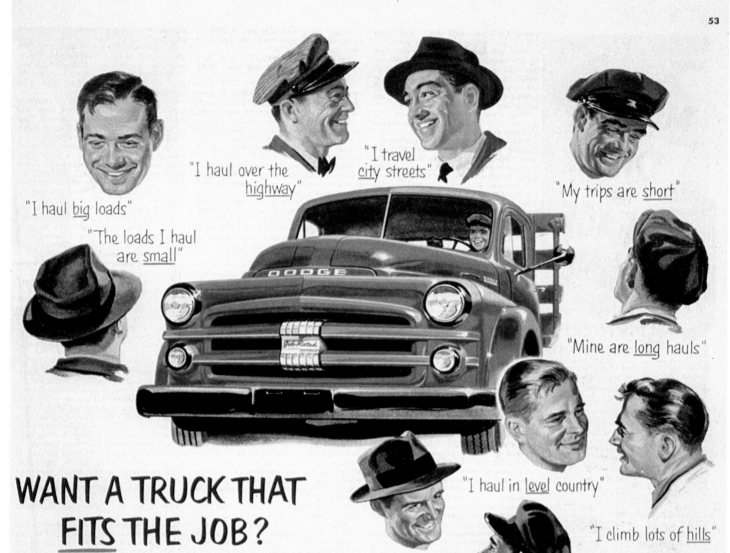

"I haul big loads"

"I haul over the highway"

"I travel city streets"

"My trips are short"

"The loads I haul are small"

"Mine are long hauls"

"I haul in level country"

"I climb lots of hills"

"I haul light goods"

"Those I haul are heavy"

WANT A TRUCK THAT FITS THE JOB?

Naturally you want a truck that's engineered to haul your loads under your operating conditions. Such a truck will save you money . . . last longer.

A Dodge *"Job-Rated"* truck is that kind of truck! Dodge builds G.V.W. chassis models to meet 98% of all hauling needs. That's why you can be sure there is a Dodge *"Job-Rated"* truck to fit your job.

Every Dodge truck unit from engine to rear axle is *"Job-Rated"*—factory-engineered to haul a specific load under specific operating conditions.

The right units to support the load

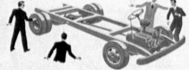

Load-supporting units—such as frames, axles, springs, wheels, and tires—are engineered and built right to provide the strength and capacity needed.

The right units to move the load

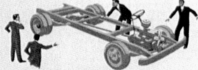

Load-moving units—such as engines, clutches, and transmissions, as well as types of rear axles and axle ratios—are engineered to provide ample power to move the load under specific operating conditions . . . quickly, dependably, at low cost.

GET A DODGE "Job-Rated" TRUCK

See your nearby Dodge dealer
Let him show you "the trucks that do the most for you"—the only trucks which have gyrol Fluid Drive available (on ½-, ¾-, and 1-ton models).

Your Dodge dealer is as close to you as your telephone. Consult the yellow pages of your phone directory for his name and address. And ask him to tell you how you can get a Dodge *"Job-Rated"* truck that will perform better on your job.

ONLY DODGE BUILDS *Job-Rated* TRUCKS

Dodge Truck

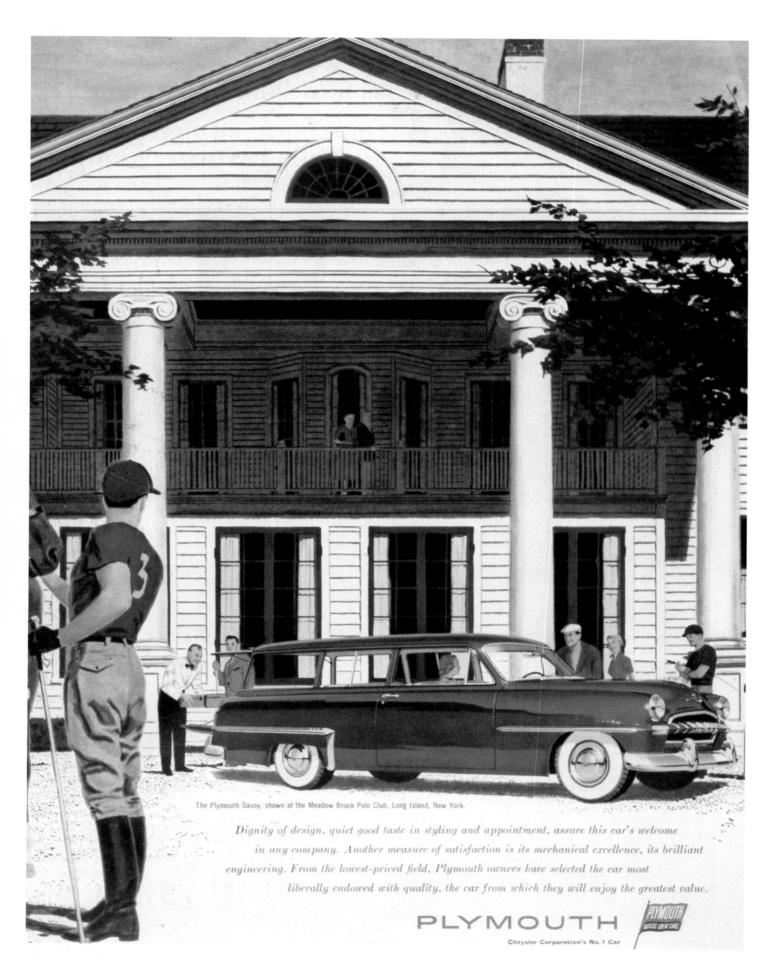

The Plymouth Savoy, shown at the Meadow Brook Polo Club, Long Island, New York.

Dignity of design, quiet good taste in styling and appointment, assure this car's welcome in any company. Another measure of satisfaction is its mechanical excellence, its brilliant engineering. From the lowest-priced field, Plymouth owners have selected the car most liberally endowed with quality, the car from which they will enjoy the greatest value.

PLYMOUTH

Chrysler Corporation's No. 1 Car

'53 Plymouth

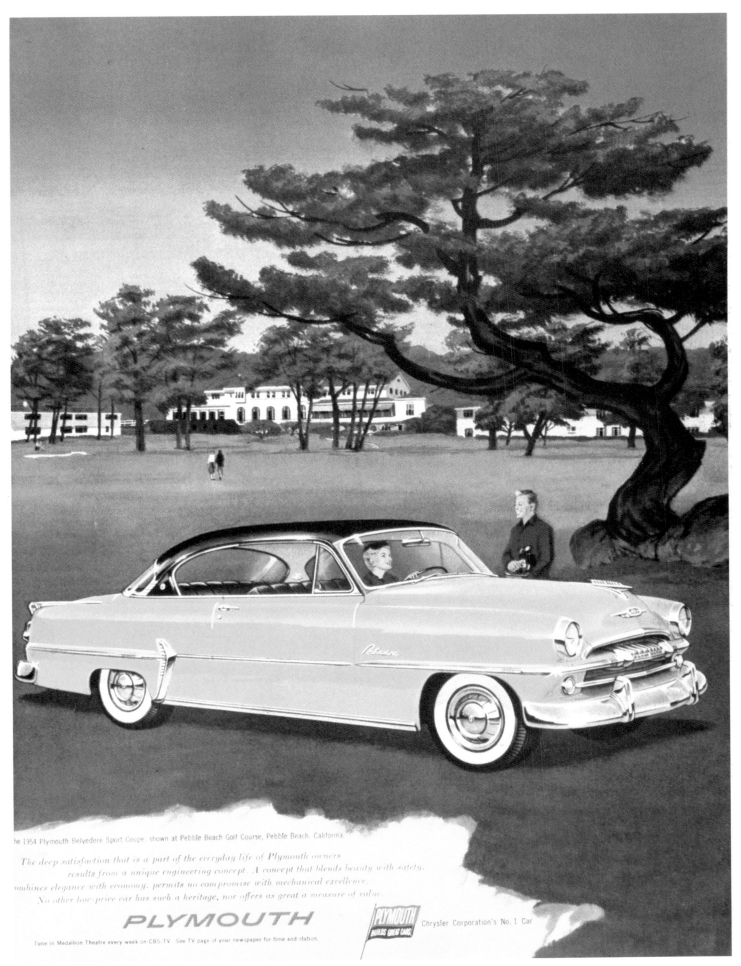

The 1954 Plymouth Belvedere Sport Coupe, shown at Pebble Beach Golf Course, Pebble Beach, California.

The deep satisfaction that is a part of the everyday life of Plymouth owners
results from a unique engineering concept. A concept that blends beauty with safety,
combines elegance with economy, permits no compromise with mechanical excellence.
No other low-price car has such a heritage, nor offers as great a measure of value.

PLYMOUTH

Tune in Medallion Theatre every week on CBS-TV. See TV page of your newspaper for time and station.

'54 Plymouth

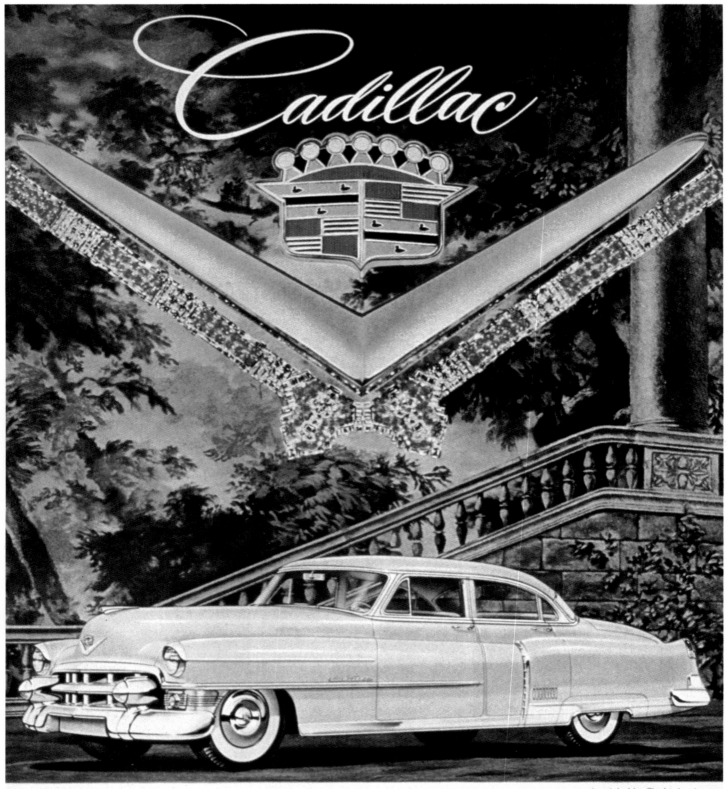

Cadillac

Jewels by Van Cleef & Arpels

The year 1953 marks the beginning of Cadillac's *second* half-century of progress in the automotive world. And there's no denying that it's a wonderful, wonderful start! You'll know what we mean the instant you see the 1953 Cadillac—for, beyond all question, it represents one of the greatest strides forward in Cadillac history. Its beauty is breath-taking as never before . . . and its new interiors, together with a new Cadillac Air Conditioner, offer unprecedented luxury and comfort. And when it comes to performance—well, its great new 210 h.p. engine, its improved Hydra-Matic Drive and its advanced Cadillac Power Steering make driving an unbelievable pleasure. Why not see and drive this new Standard of the World at your earliest opportunity? We know you'll agree that it's the perfect start for *another* great era of Cadillac leadership!

CADILLAC MOTOR CAR DIVISION ★ GENERAL MOTORS CORPORATION

'53 Cadillac

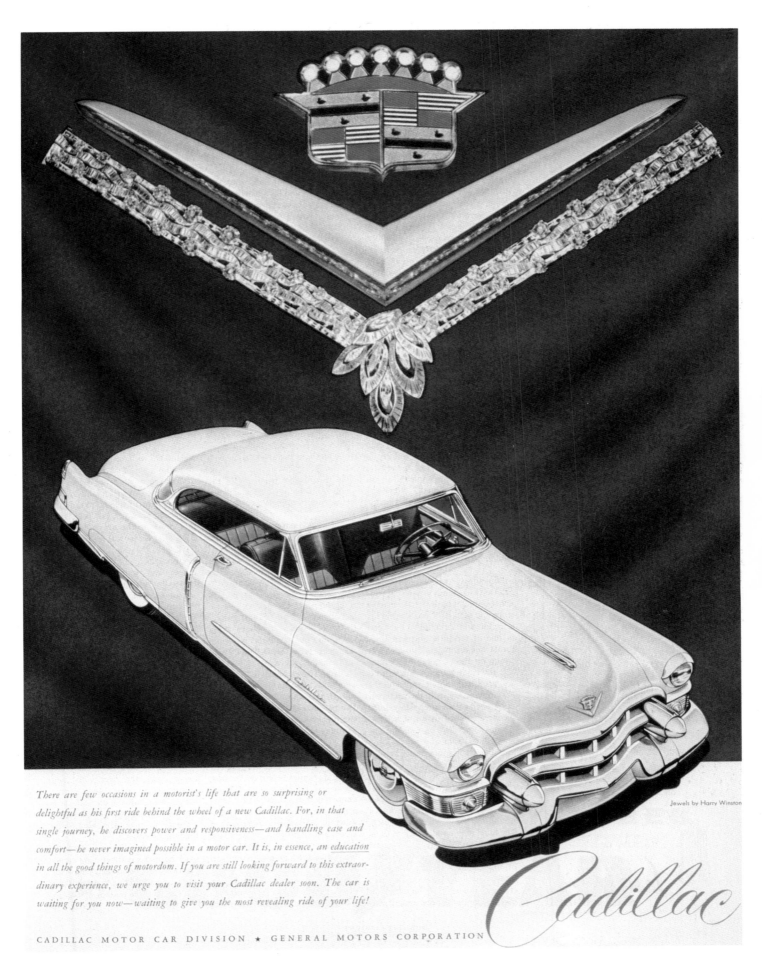

There are few occasions in a motorist's life that are so surprising or delightful as his first ride behind the wheel of a new Cadillac. For, in that single journey, he discovers power and responsiveness—and handling ease and comfort—he never imagined possible in a motor car. It is, in essence, an _education_ in all the good things of motordom. If you are still looking forward to this extraordinary experience, we urge you to visit your Cadillac dealer soon. The car is waiting for you now—waiting to give you the most revealing ride of your life!

Jewels by Harry Winston

Cadillac

CADILLAC MOTOR CAR DIVISION ★ GENERAL MOTORS CORPORATION

'53 Cadillac

61

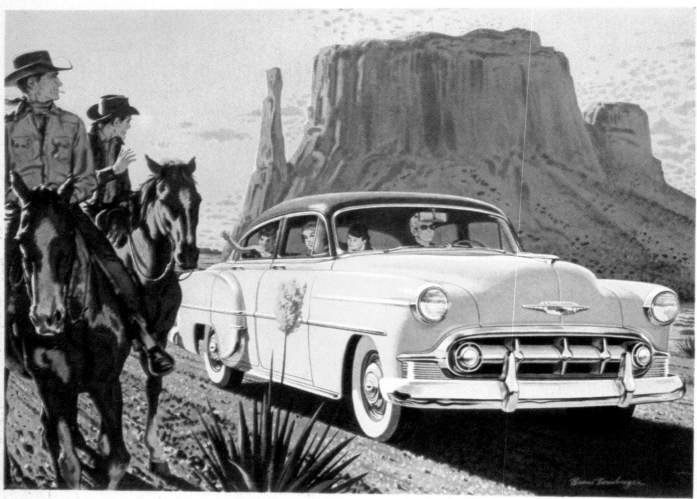

The thrilling new "Two-Ten" 4-door Sedan, one of 16 beautiful models in 3 great new series.

What's back of Chevrolet's sensational new gasoline economy . . .

The smiling people in this picture have been traveling since early morning; and, much to their pleasure, they are having a remarkably *thrifty* trip.

You see, the 1953 Chevrolet makes gasoline go a *lot* farther—in fact, brings you the most important gain in economy of *any* new Chevrolet in history—due to outstanding improvements made by Chevrolet engineers.

New higher compression ratios in the 115-h.p. "Blue-Flame" engine with Powerglide* and the 108-h.p. "Thrift-King" engine with standard transmission have boosted power output greatly while cutting gasoline consumption sharply.

Consequently, Chevrolet owners everywhere are highly enthusiastic about the twin gains of improved performance and economy in these most advanced cars in the entire low-price field.

We cordially invite you to visit your Chevrolet dealer's and experience the sensational new performance and economy of the 1953 Chevrolet at your earliest convenience.

And also to enjoy the *many other exclusive advantages* which are causing people to pronounce this car the first buy of the land! . . .

Chevrolet's new Powerglide automatic transmission, coupled with the entirely new 115-h.p. valve-in-head engine (highest compression engine in its field) now provides automatic getaway in low and automatic pick-up for passing in traffic. Results: Much fleeter performance, important new gasoline savings, and the finest no-shift driving in Chevrolet's price range.

New Fashion-First Bodies by Fisher bring you beauty, comfort and safety fully as outstanding as

Chevrolet's new performance and economy. Interiors are richer, roomier, and *color-matched* with exteriors in "Two-Ten" and Bel Air models.

You'll park and steer with finger-tip ease, and enjoy greater safety as well, thanks to new Power Steering,* the most vital improvement since automatic driving, and exclusive to Chevrolet in its field.

Improved Velvet-Pressure Jumbo-Drum brakes (largest in Chevrolet's field) and the softer, smoother Knee-Action Ride give maximum comfort and safety. See this wonderful new Chevrolet — America's *lowest-priced* full-size car — at your Chevrolet dealer's now. . . . Chevrolet Division of General Motors, Detroit 2, Michigan.

Optional at extra cost. Combination of Powerglide automatic transmission and 115-h.p. "Blue-Flame" engine available on "Two-Ten" and Bel Air models only. Power Steering available on all models.

MORE PEOPLE BUY CHEVROLETS THAN ANY OTHER CAR!

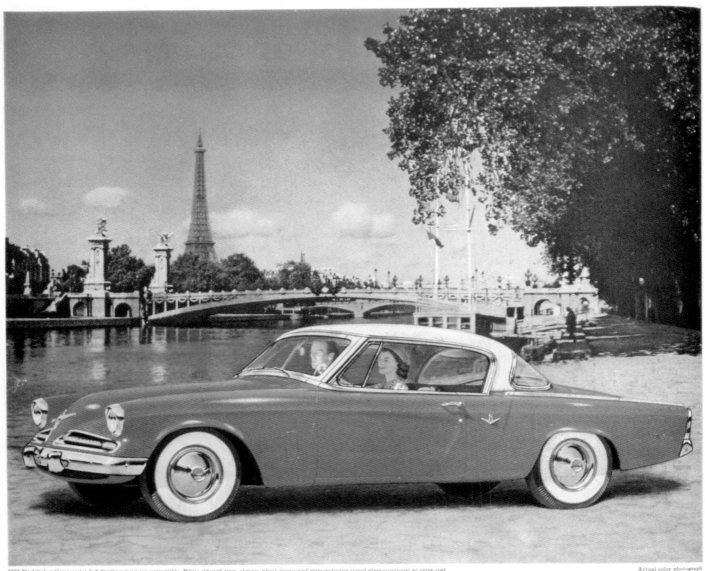

1953 Studebaker Commander V-8 Starliner hard-top convertible. White sidewall tires, chrome wheel discs—and glare-reducing tinted glass—optional at extra cost

Actual color photograph

the new American car with the European look!

It's the breath-taking new 1953 Studebaker!
Excitingly new in continental styling!
Impressively down to earth in price!

THIS dramatic new Studebaker comes to you straight out of the dream book.

It brings you the continental charm of Europe's most distinguished cars. But it's thoroughly American in deep-down comfort and in handling ease.

Long and racy and sparkling with drive appeal, every 1953 Studebaker gleams with an enormous expanse of glass for full vision. Every distinctive body style is completely and spectacularly new both inside and outside.

All this at a down-to-earth price—with Studebaker low operating cost!

Order your Studebaker now. Get a Champion in the lowest price field or a brilliant-performing Commander V-8.

Motoring's finest power steering is available in all Studebaker models at moderate extra cost.

New 1953 Studebaker

It's a startler! It's a Starliner—the new 1953 Studebaker hard-top!
Truly a new flight into the future! Less than five feet high!

'53 Studebaker

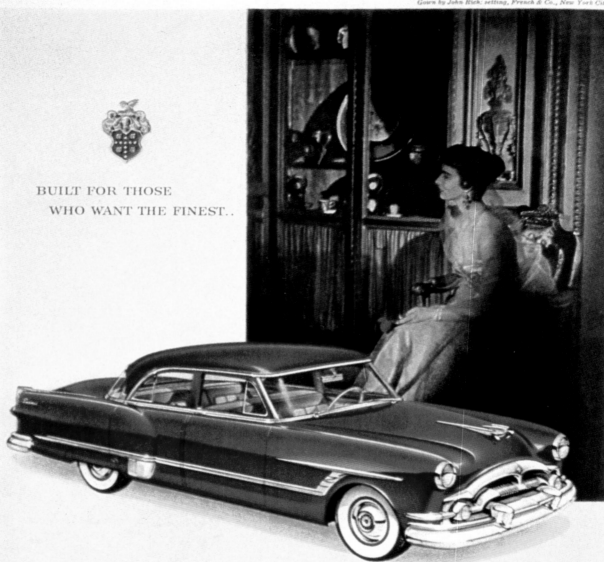

BUILT FOR THOSE
WHO WANT THE FINEST..

America's Most Advanced New Car

PACKARD

DISTINCTION speaks in many ways—but never more eloquently than when you drive America's new choice in the fine-car field—Packard for 1953!

DESIGNED AND BUILT for those who want the very best, Packard offers you a selection of seven distinguished models.

HERE YESTERDAY'S TRADITIONS of craftsmanship join tomorrow's engineering to bring you everything you have desired in a car—the incredible smoothness of the Packard ride, for example . . . and the hush of the world's highest-compression eight when "loafing" at sixty!

IT IS SIGNIFICANT that Packard, which owes allegiance to no other brand name, builds the one car expressing *real individuality*—both its own and that of its owner.

NOW . . . ASK THE MAN WHO OWNS ONE

See The Exciting New Packard CLIPPER *For Big-Car Value At Medium-Car Cost*

'53 Packard

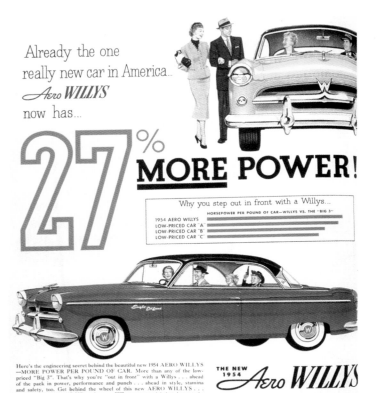

65

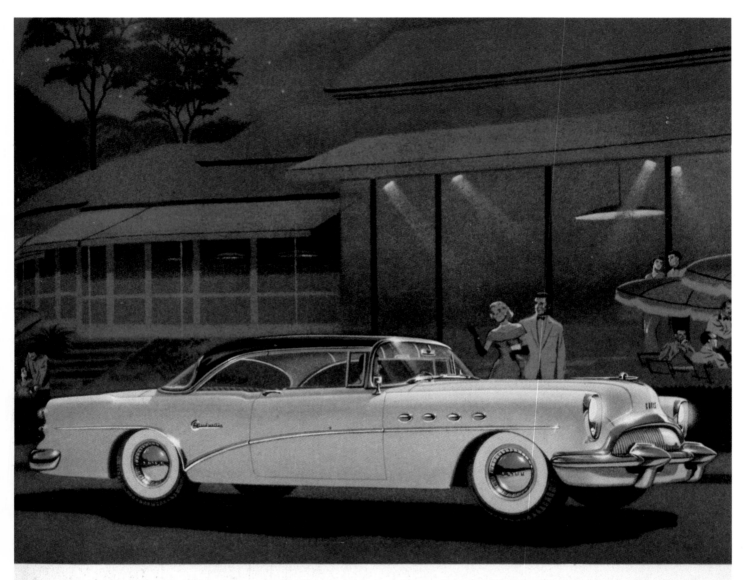

You can make your "someday" come true now

YOU promised yourself, didn't you, that someday you would own a car that came up to your dreams?

That it would be a car of stature and distinction? That it would be luxuriously smooth and supremely able? That it would look and feel and perform the part of the car of a man at the top?

Well, sir—today can be that day.

For such a car is at hand now, more easily attainable than you may think. You see it pictured here, and the name is proudly spelled out on each rear fender: ROADMASTER.

It is custom production. Its appointment is subject to your individual taste. Its quality is the best that Buick builds. *Its price per pound is the lowest in the fine-car field.*

But apart from its impressive length and breadth and breath-taking beauty (it carries the world's newest body, with the panoramic visibility of Buick's famed sweep-back windshield)—this superb automobile is an automobile of supreme command.

When you drive it you will know that this is so.

When you hold reign on ROADMASTER's magnificent V8 power, feel the smooth tranquility of Twin-Turbine Dynaflow, feather your way with the consummate ease of Safety Power Steering, sense the solid velvet of Buick's buoyant ride — then you will know that this is the car you always meant to own "someday."

So why wait? Call your Buick dealer today, or the first thing tomorrow. He'll gladly arrange a ROADMASTER demonstration and you can judge things from there.

BUICK *Division of* GENERAL MOTORS

ROADMASTER *Custom Built by* BUICK

'54 Buick Roadmaster

New Power Braking, Power Steering, Electric Window Lifts, Comfort-Control Seat, Air Conditioning and Dual-Range Hydra-Matic Drive are optional at low extra cost to heighten your pleasure and pride in your Pontiac.

Dollar for Dollar You Can't Beat a

PONTIAC

A GENERAL MOTORS MASTERPIECE

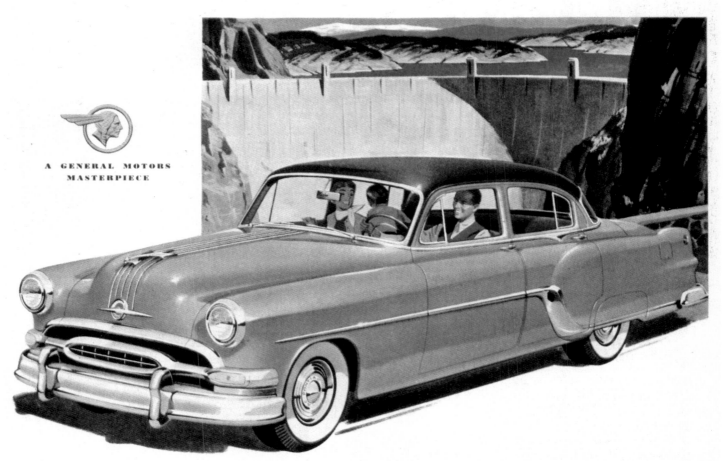

Something Totally New in Pontiac's Low Price Range!

Now you can stay in Pontiac's low price range and still move right up to fine-car ownership. That is the wonderful opportunity presented to you by the new Chieftain Pontiac—the pace-setter for high quality at low cost.

The car is a gem—distinguished enough in line and contour to win applause in any company . . . splendid enough inside to win the hearts of the

most style-minded . . . and roomy enough to carry a carful in luxurious and relaxing comfort for hours and hours on end.

Performance is just as prideful. An even mightier engine for 1954 moves you where you want to be, *when* you want to be there, with an easy, quiet flow of power that keeps you contented every mile of the way. Yet economy is still a con-

spicuous Pontiac virtue—together with a record for reliability unduplicated by any other automobile power plant.

Take a look at General Motors lowest priced eight. Take a ride as well. Note that the price is near the lowest you will pay for any new car. Then let your own good judgment tell you why—dollar for dollar you can't beat a Pontiac.

DON'T MISS DAVE GARROWAY'S NIGHTTIME SHOW—NBC-TV · PONTIAC MOTOR DIVISION OF GENERAL MOTORS CORPORATION

'54 Pontiac

67

Safest place for your truck dollars—
new Chevrolet trucks!

New Chevrolet trucks handle your dollars with care right from the start. They're America's lowest-priced truck line, you know.

And over the miles, they keep a watchful eye on your dollars right down to the penny. Things like new high-compression power and greater chassis ruggedness in all new Chevrolet trucks mean lower operating and upkeep costs. What truck owner doesn't want that!

When it comes time to trade in your Chevrolet truck, you discover again what a safe and wise investment you made—for Chevrolet trucks traditionally have a high resale value.

Stop in and see your Chevrolet dealer for the safest — and "savingest" — truck deal you ever made! . . . Chevrolet Division of General Motors, Detroit 2, Michigan.

New Chevrolet trucks offer
more advantages you need and want—

New Engine Power: Brawnier "Thriftmaster 235" engine. Rugged "Loadmaster 235." All-new "Jobmaster 261" engine.*

New Comfortmaster Cab: Offers new comfort, safety and convenience. New one-piece curved windshield provides extra visibility.

New Chassis Ruggedness: Heavier axle shafts in 2-ton models . . . newly designed clutches, and more rigid frames in *all* models.

New Ride Control Seat: * Seat cushion and back move as a unit to eliminate back-rubbing. It "floats" you over rough roads with ease.

New Automatic Transmission: * Proved truck Hydra-Matic transmission is offered on ½-, ¾- and 1-ton models.

New, Bigger Load Space: New pickup bodies have deeper sides. New stake and platform bodies are wider, longer and roomier.

*Optional at extra cost. Ride Control Seat is available on all cabs of 1½- and 2-ton models, standard cabs only in other models. "Jobmaster 261" engine available on 2-ton models.

CHEVROLET TRUCKS
Most Trustworthy Trucks on Any Job!

Chevrolet Truck

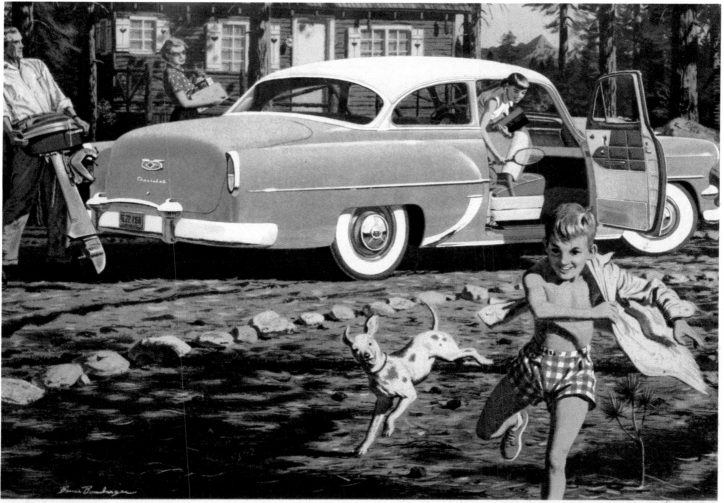

The new 1954 Chevrolet Delray Coupe. With three great series Chevrolet offers the most beautiful choice of models in its field.

Four good reasons why new Chevrolet families are "having a wonderful time"...

That family up there has everything it takes to enjoy a wonderful vacation—a fine place to go and a fine new Chevrolet to get them there.

In fact, no other car fits so beautifully into all your family activities all the year 'round.

FIRST OF ALL, there's a lot of pride and pleasure for you in Chevrolet's lasting good looks. It's the only low-priced car with Body by Fisher. And *that*, you know, means smarter styling outside and in, and more solid quality through and through. You'll see it in the finer workmanship and materials, the greater comforts and conveniences.

THEN THAT FINE AND THRIFTY Chevrolet performance is always a special pleasure. Chevrolet's high-compression power—highest of any leading low-priced car—brings smoother, quicker response and

important gasoline savings, too. Here's one car that's really easy to handle and park on shopping trips, and that gives you solid and steady big-car comfort on vacation trips.

AND BEST OF ALL, MAYBE, is the eager, quiet, un-complaining way your Chevrolet keeps on going wherever and whenever you want to go. You can count on it to start quickly and run smoothly night or day, fair weather or foul. You won't find another car with such a great name for serving its owners reliably and economically over a long life.

FOURTH BUT NOT LEAST, your Chevrolet dealer will be glad to show you how beautifully a new Chevrolet will fit your budget, too. For Chevrolet is priced below all other lines of cars.... Chevrolet Division of General Motors, Detroit 2, Michigan.

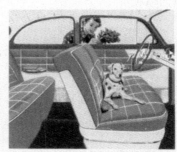

BRIGHT NEW IDEA IN INTERIORS! The interior of the new Chevrolet Delray Club Coupe is all vinyl, in colors that harmonize with the exterior finish. It's as practical as it is beautiful, for the vinyl is easily washable and amazingly resistant to scuffing and wear.

SYMBOL OF SAVINGS
CHEVROLET
EMBLEM OF EXCELLENCE

YEAR AFTER YEAR MORE PEOPLE BUY CHEVROLETS THAN ANY OTHER CAR!

'54 Chevrolet

69

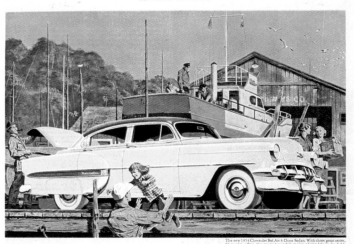

THE SATURDAY EVENING POST

The new 1954 Chevrolet Bel Air 4-Door Sedan. With three great series, Chevrolet offers the most beautiful choice of models in its field.

Some sensible reasons why it's more <u>fun</u> to own a Chevrolet...

Maybe we can't all be quite as lucky as the man in our picture. Not everyone has a blue-jeaned daughter with a touch of tomboy in her to take fishin'.

But you can share his pleasure in going places in that new Chevrolet. It's engineered to be just plain *fun* to own, from the day you drive it home until the day you trade it in.

IT PUTS THE PLEASURE BACK IN DRIVING. Here's one car that's *easy* to handle in today's traffic. You really get a kick out of its quick, quiet response to your foot on the accelerator (highest compression power of any leading low-priced car). You feel good about the smooth, easy way it stops on a dime (biggest brakes in the low-price field). You sense with relaxing pleasure that you've got a lot of car under you (only car in its field with the extra strength of Fisher Unisteel

Construction and a full length box-girder frame).

IT'S <u>FUN</u> TO BE THRIFTY in a new Chevrolet. And you *are* thrifty. For this fine, big Chevrolet is priced below all other lines of cars. And Chevrolet's great name for economy of operation and upkeep is growing even greater this year. That new high-compression power means not only more fun per gallon, but important gasoline savings as well!

SURE AS SEA WATER'S SALTY, your Chevrolet dealer has just the right model to make a gay and carefree companion for your family fun. Let him show you how Chevrolet, as the world's largest builder of automobiles, can give you more car for your money. And while you're there, be sure you *drive* this new Chevrolet —if only for the fun of it.... Chevrolet Division of General Motors, Detroit 2, Michigan.

NOW AUTOMATIC WINDOW AND SEAT CONTROLS. This year's Chevrolet offers you any or all of the latest automatic power features and controls. If you like, you can have the extra-cost options of Automatic Front Window and Seat Controls on Bel Air and "Two-Ten" models, and Power Brakes on Powerglide models, as well as Power Steering and zippy Powerglide on all models.

MORE PEOPLE BUY CHEVROLETS THAN ANY OTHER CAR! **CHEVROLET** SYMBOL OF SAVINGS EMBLEM OF EXCELLENCE

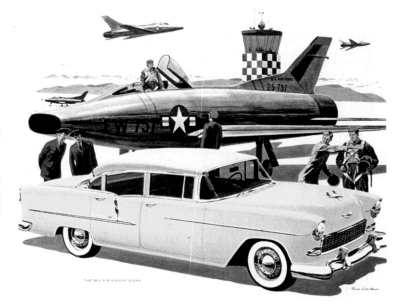

THE BEL AIR 4 DOOR SEDAN

Chevrolet's <u>3</u> <u>new</u> <u>engines</u> put new fun under your foot and a great big grin on your face!

You'll want to read about the <u>new</u> <u>V8</u> and <u>two</u> <u>new</u> <u>6's</u> here.

But it's even better to let them speak for themselves on the road.

You've got the greatest choice going in the Motoramic Chevrolet! Would you like to boss the <u>new</u> "Turbo-Fire V8" around . . . strictly in charge when the light flashes green . . . calm and confident when the road snakes up a steep grade? (Easy does it— you're handling 162 "horses" with an 8 to 1 compression ratio!) Or would you prefer the equally thrilling performance of one of the two new 6's? There's the <u>new</u> "Blue-Flame 136" teamed with the extra-cost option of a smoother Powerglide. And the <u>new</u> "Blue-Flame 123" with either the new standard transmission or the extra-cost option of <u>new</u> <u>Touch-Down Overdrive</u>. See why Chevrolet is stealing the thunder from the high-priced cars! It has that high-priced, high-fashion look and everything good that goes with it—power, drives, ride, handling ease, *everything*. Let your Chevrolet dealer demonstrate how Chevrolet and General Motors have started a whole new age of low-cost motoring! . . . Chevrolet Division of General Motors, Detroit 2, Michigan.

Motoramic **CHEVROLET** *More than a new car . . . a new* <u>concept</u> *of low-cost motoring!*

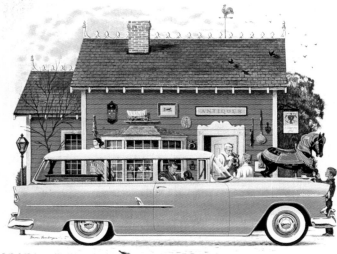

The "Two-Ten" Handyman—one of Chevrolet's fine beautiful new Station Wagons with Body by Fisher.

<u>Never</u> have you seen Station Wagons as wonderful as the new Chevrolets!

They're <u>handsome</u> (just look!). They're <u>handy</u> (new seat fold provides nearly 11 inches more cargo deck!).

Two doors or four, V8 or 6, three modern transmissions—and a wagonload of other new things you want.

You can have your cake and eat it, too—with Chevrolet's spanking-new line of Station Wagons! For here is sophisticated big-city style (and the longest look of any Chevrolet) . . . plus pack-horse performance and astonishing new utility features. Now, both the rear seat cushion and the backrest fold flush with the floor to give almost 11 inches *more* cargo space. Curved rear quarter windows combine with the deep Sweep-Sight Windshield to give visibility unlimited. With this two-in-one versatility you get all of Chevrolet's great engineering advances—the 162-h.p. "Turbo-Fire V8" or the two new "Blue-Flame" 6's, the smoothness of Glide-Ride front suspension, the stability of outrigger rear springs, Anti-Dive braking control, 12-volt electrical system and new Synchro-Mesh transmission. Plus your choice of extra-cost options such as Powerglide automatic transmission or Overdrive, Power Steering, Power Brakes—even Air Conditioning (on V8 models). How versatile can a car be? Why not call your Chevrolet dealer and see? . . . Chevrolet Division of General Motors, Detroit 2, Michigan.

More than a new car **CHEVROLET** *a new* **concept** *of low-cost motoring*

Chevrolet Bel Air Convertible with Body by Fisher.

Blue-ribbon beauty
that's stealing the thunder from the high-priced cars!

Wherever outstanding cars are judged . . . for elegance, for comfort, for beauty of line . . . a surprising thing is happening. The spotlight is focusing on the new Chevrolets with body by Fisher.

Surprising—because Chevrolet offers one of America's lowest-priced lines of cars. But not really astonishing when you consider that its team of internationally famous engineers and stylists spent three years creating the 1955 models, and that they had just one goal—to shatter all previous ideas about what a low-priced car could and should be.

The unparalleled manufacturing efficiency of Chevrolet and General Motors provided the *means*—and that's why you have a

low-priced car that looks like a custom creation. That's why you get the thistledown softness of Glide-Ride front suspension—but married to the sports-car stability of outrigger rear springs. That's why you can choose between a hyper-efficient 162-h.p. V8 engine, or two brilliant new 6's. That's why Chevrolet's array of extra-cost options includes every luxury you might want—Powerglide, Overdrive, Power Brakes and Steering, even Air Conditioning on V8 models. And that's why you should try a Chevrolet for the biggest surprise of your motoring life! . . . Chevrolet Division of General Motors, Detroit 2, Michigan.

Motoramic **CHEVROLET** *Drive it at your Chevrolet dealer's*

HOLIDAY / MAY

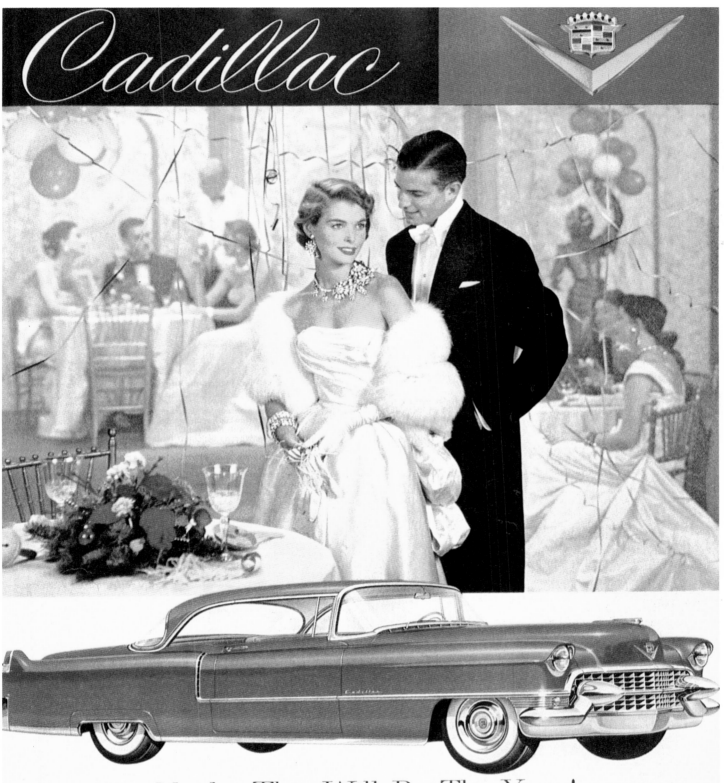

Maybe This Will Be The Year !

The handsome couple you see in the beautiful picture above have just made a very wise decision.

They have decided to get the facts about Cadillac—to see if, perhaps, the time has come for them to make the move to the "car of cars."

And we hope sincerely that 1955 *will* be their Cadillac year. For this, beyond any question, is the *perfect* year to discover the joys of Cadillac ownership!

Never before has the car offered so much by way of beauty, or luxury, or performance. It is inspiring to behold . . . and thrilling to drive . . . and wonderful to own—to a degree unprecedented even by Cadillac.

And it is even more practical to own and operate. Its gasoline economy will surprise even the most

veteran Cadillac owner—and it is designed and buil to provide years of dependable, trouble-free service

If a new Cadillac is high on your list of hopes fo the new year, we think you should give careful con sideration to these facts. And we suggest that you mak a "resolution" now—to drive the 1955 Cadillac!

Your dealer will be happy to see you at any time!

CADILLAC MOTOR CAR DIVISION · GENERAL MOTORS CORPORATION

'55 Cadillac

Avalon Yellow AND RAVEN BLACK!

Perfect choice for the bright new star of the highway

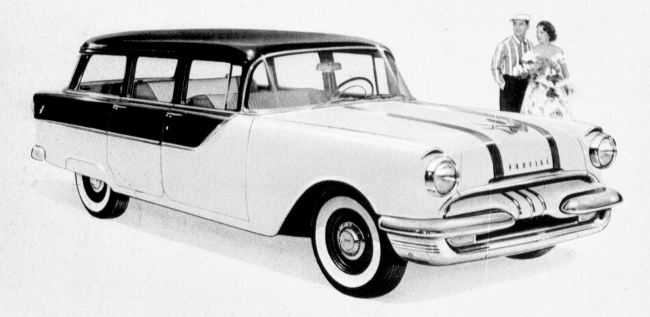

Avalon Yellow, bright omen of the shining hours awaiting
you in a Pontiac, here adorns an American beauty—the Pontiac Station
Wagon. Happiest possible meeting of smartness and utility, this Strato-
Streak powered beauty is also an extraordinarily gifted performer.
There's a pleasant way to prove it. See your Pontiac dealer
and drive the car—today!

Pontiac V8

with the sensational Strato-Streak

PONTIAC MOTOR DIVISION, GENERAL MOTORS CORPORATION

Bolero Red

AND RAVEN BLACK!

Heartlifting hue
for a heartlifting car

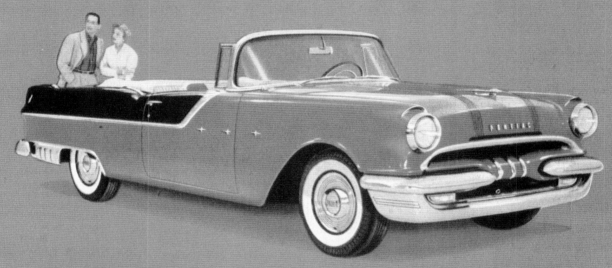

Here's a car that turns heads wherever it goes—a distinguished
Pontiac beauty! You'll approve as heartily of Strato-Streak V-8
performance . . . an achievement as dynamically different as Pontiac's future-
fashioned style. The price is equally appealing. It's way below your
expectations and exactly in line with your hopes. Step straight into
tomorrow—drive a Pontiac, today!

Pontiac V8

with the sensational Strato-Streak

PONTIAC MOTOR DIVISION, GENERAL MOTORS CORPORATION

'55 Pontiac

73

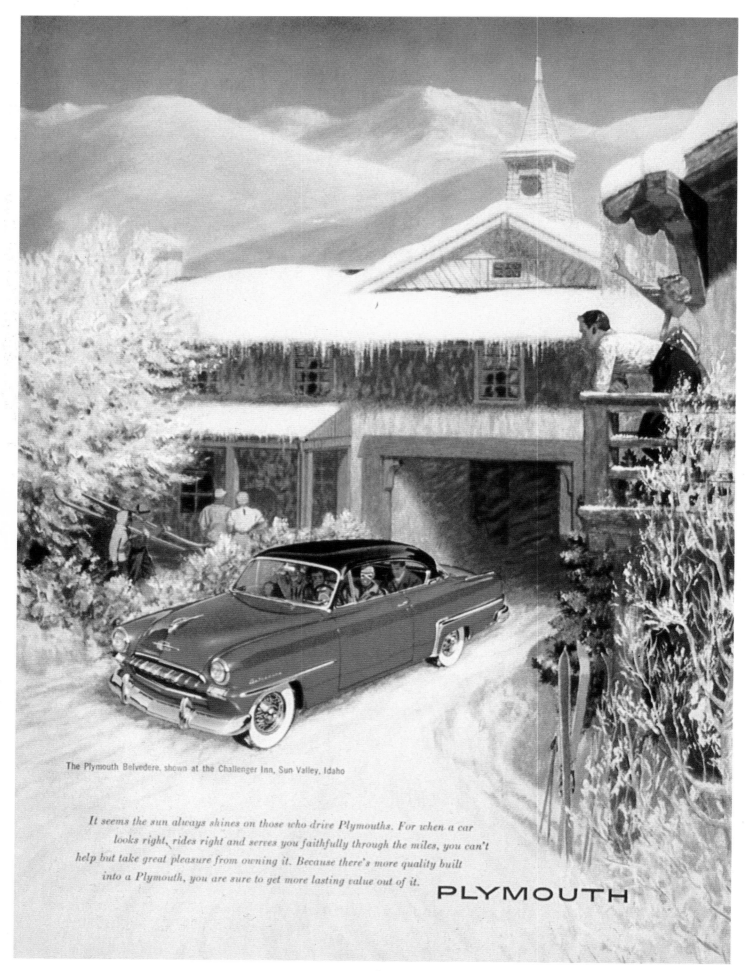

The Plymouth Belvedere, shown at the Challenger Inn, Sun Valley, Idaho

It seems the sun always shines on those who drive Plymouths. For when a car looks right, rides right and serves you faithfully through the miles, you can't help but take great pleasure from owning it. Because there's more quality built into a Plymouth, you are sure to get more lasting value out of it.

PLYMOUTH

'53 Plymouth

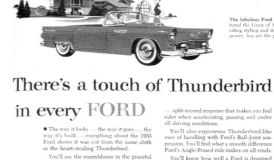

The fabulous Ford Thunderbird which has captured the fancy of America with its long, low exciting styling and its split-second Trigger-Torque power, has set the pace for all '55 Fords.

There's a touch of Thunderbird in every FORD

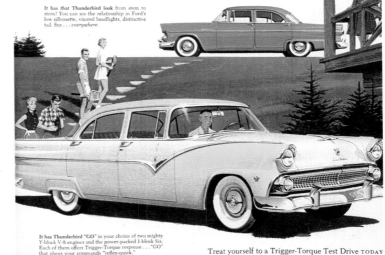

● The way it looks... the way it goes... the way it's built... *everything* about the 1955 Ford shows it was cut from the same cloth as the heart-stealing Thunderbird.

You'll see the resemblance in the graceful flair of Ford's long, low lines... and in the skillful harmonizing of interior colors.

You'll feel the kinship in the reflex-quick obedience of Ford's Trigger-Torque power

...split-second response that makes you feel safer when accelerating, passing and under all driving conditions.

You'll also experience Thunderbird-like ease of handling with Ford's Ball-Joint suspension. You'll find what a smooth difference Ford's Angle-Poised ride makes on all roads.

You'll know how well a Ford is designed and built, too! For Ford shares the same kind of engineering, the same quality standards that have won first place for the Thunderbird in the hearts of so many.

It has that Thunderbird look from stem to stern! You can see the relationship in Ford's low silhouette, visored headlights, distinctive tail fins... *everywhere.*

It has Thunderbird "GO" in your choice of two mighty Y-block V-8 engines and the power-packed I-block Six. Each of them offers Trigger-Torque response... "GO" that obeys your commands "reflex-quick."

Treat yourself to a Trigger-Torque Test Drive TODAY

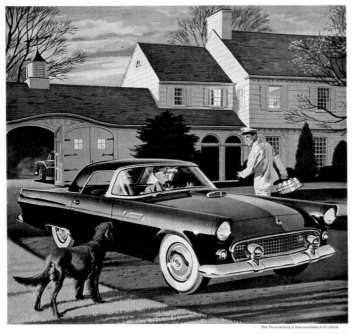

6 a.m. THUNDERBIRD time

The Thunderbird is now available in 5 colors!

Doctor, Lawyer, Merchant, Chief—no matter who you are—you'll find yourself getting up early when your garage is home to a Thunderbird. For here is a truly delightful package of sheer pleasure—all the way from its "let's go" look to the "let's go" performance of its Thunderbird Special Y-block V-8.

What's more—that seat is nearly *five* feet wide and it's power-operated. A touch of a switch moves it *up, down*—forward or back to suit your requirements for driving comfort. The steering wheel is

another comfort feature—adjust it as you like it.

As for weather—your Thunderbird can have an easily demountable hard top *and/or* a snug fabric top that folds away completely out of sight. Windows roll up... power-operated if you like. Power steering, power brakes, Overdrive and Speed-Trigger Fordomatic are also available. These are important details, but the main thing is the low and mighty car itself! Why don't you obey that urge and try one today? Your Ford Dealer is the man to see.

This is the Thunderbird Special Y-block V-8 4-barrel carburetor, 8.5 to 1 compression ratio, 198-h.p. with Fordomatic... try it!

An exciting original by FORD

HOLIDAY/JUNE

Take command...get the thrill first hand!

It's dashing! It's dazzling! But don't think for a minute that *flair-fashioned beauty* is the whole Dodge story! Along with its luxury-car length and brilliant style, this new Dodge packs the greatest *thrill of command* on the road today. It more than lives up to its looks in surging power, unbelievable handling ease. It is *dependable* as only a Dodge can be dependable. Want to find out? *Take command...get the thrill first hand!*

Drive the New

DODGE

Daringly new for Spring! Dashing Custom Royal Lancer four-door... the flair of a hardtop—the roominess of a sedan.

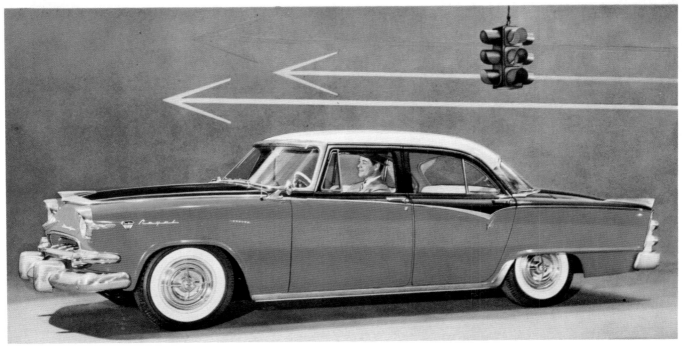

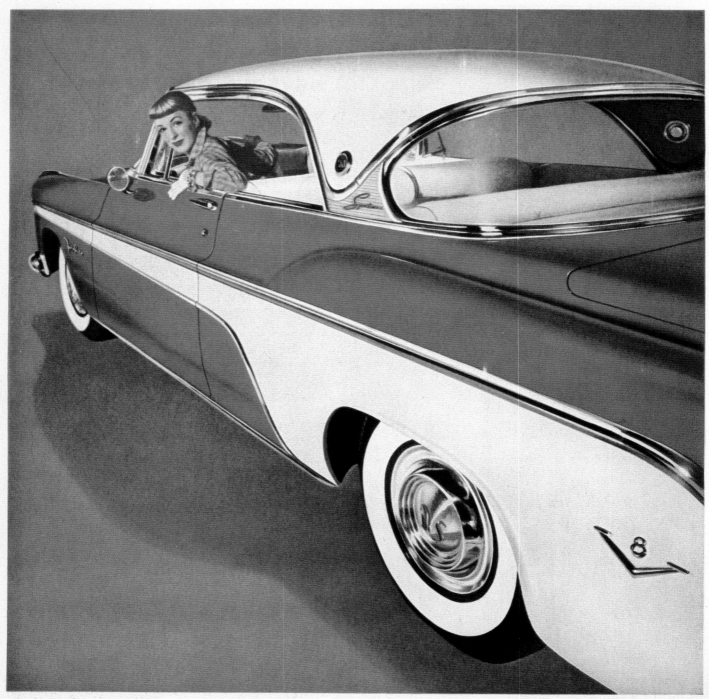

Anne Fogarty, famous fashion designer, drives a De Soto Sportsman.

DRIVE A [DE SOTO] BEFORE YOU DECIDE

There is no word in the English language that quite describes the utter satisfaction, the thrill, the delightful ease of driving a De Soto. Here is a car that translates your wishes into action almost with the speed of thought itself. There is an eager, natural response that is quite different from anything you're likely to find in other cars. That is why it is really important that you "drive a De Soto before you decide!" Your De Soto dealer will be delighted to have you take a turn at the wheel of either a Firedome or Fireflite. De Soto Division, Chrysler Corporation.

DE SOTO-PLYMOUTH dealers present **GROUCHO MARX** in "YOU BET YOUR LIFE" on NBC RADIO and TV

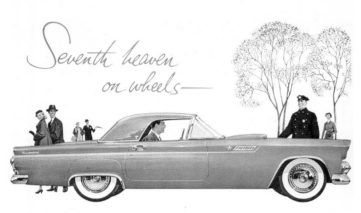

Seventh heaven on wheels—

the Ford THUNDERBIRD

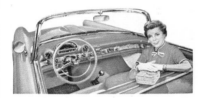

Wherever—whenever—your Thunderbird appears in public, the effect is electric. All eyes turn to its long, low, graceful beauty. All hearts say "That's for me!"

And if they only knew the full story!

If they could spend but half an hour in your seat, if they could listen to the dual-throated harmony of its tuned mufflers and twin exhausts, if they could feel the steepest hills melt before the might of the 198-h.p. Thunderbird Special V-8, if they could see the tachometer needle wind up, as the four-barrel carburetor and 8.5 to 1 compression ratio convert gasoline into road-ruling Trigger-Torque "Go!"

Then they'd sample a portion of your pride in your personal car. But you could show them more!

You could show them the way it takes the corners as if magnetized to the road. You could let them feel the lightning "take-off" with new Speed-Trigger Fordomatic Drive. You could show them how quickly the convertible top whisks into place—how easily the solid top lifts on and off—the all-steel body—the ample trunk space—the rich interiors—the telescoping steering wheel—the 4-way power seat. And should your Thunderbird have the optional power assists, they could note the convenience of power steering, power brakes and power window lifts.

You could show them this and more—how even routine driving becomes thrilling entertainment.

Yes, we're day-dreaming for you. But why not put yourself in the driver's seat and make this dream come true! The man to see is your Ford Dealer.

An exciting original by FORD

Which one of these Chevrolet sport models would you rather have fun with?

Are you the type that likes to breeze along the open road on a bright summer day with nothing above between you and the blue? Do you like the sound of rain against a snug fabric top? If so, that Chevrolet Convertible in our picture is for you! No question about it. For here's a car that's as young in spirit as you are—and looks it! Even the smart all-vinyl interior is made to live outdoors.

But maybe you like a car that can carry anything from small fry to outboard motors with equal ease. That would be the "Two-Ten" Handyman Station Wagon you see over there (one of five Chevrolet station wagons). Here's one car that's so versatile it practically makes you a two-car family all by itself. So low it sets a new height of fashion for station wagons! Practical? If the kids track sand inside, you can wash it out in a jiffy.

On the other hand, if you go for hardtop—and like 'em long, low and dashing—that Bel Air Sport Coupe in the background is just your dish. It's a "show car" from the word go!

Whichever Chevrolet you choose, you're bound to have the driving time of your life! You can't miss with Chevrolet's new 162-h.p. "Turbo-Fire V8" under the hood (180 h.p. is an extra-cost option in all V8 models), or with one of the two highest powered 6's in the low-price field. Your Chevrolet dealer is the man to see. . . . Chevrolet Division of General Motors, Detroit 2, Michigan.

STEALING THE THUNDER FROM THE HIGH-PRICED CARS!. . . *motoramic* CHEVROLET

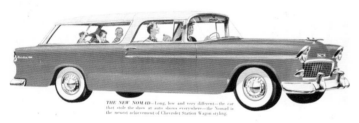

THE NEW NOMAD—Long, low and very different—the car that stole the show at auto shows everywhere—the Nomad is the newest achievement of Chevrolet Station Wagon styling.

Stylish Wagons by Chevrolet!

More and more people are joining the Station-Wagon set—and no wonder, with this spanking quintet of Motoramic Chevrolet wagons to choose from! Beautifully styled inside and out and with space to spare . . . from the luxurious Nomad to the rugged Handyman, an entirely new concept of stylish low-priced Station Wagons. See them soon at your Chevrolet dealer's. . . . Chevrolet Division of General Motors, Detroit 2, Mich.

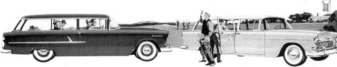

THE "TWO-TEN" HANDYMAN—At work or at play, this 2-door Station Wagon is a pleasure to look at—a joy to drive. Front-seat backs swing way up for easy access to rear seat and cargo area. Interiors—even roof linings—are of colorful, tough and easily washable vinyl.

THE BEL AIR BEAUVILLE—The rakish dash of the Bel Air sport series combines with utility in this sleek 4-door model. Only Chevrolet in the low-price field gives you "Sweep-Sight" vision, fore and aft—shoulder-to-shoulder windshields and curved rear quarter windows.

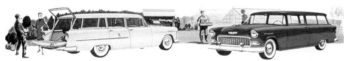

THE "TWO-TEN" TOWNSMAN—Rugged and handsome in every detail—because Chevrolet gives you something no other low-priced car can . . . Body by Fisher. Extra tough under the hood, too; your choice of two new "Blue-Flame" 6's or the surging new "Turbo-Fire V8."

THE "ONE-FIFTY" HANDYMAN—Like all Chevrolet Station Wagons, this 2-door boasts more load length than ever—fully ten extra inches, for both rear seat back and cushion fold into the floor. "Glide-Ride" front suspension and outrigger rear springs give new driving ease.

Stealing the thunder from the high-priced cars!

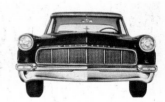

Now, in America, a refreshing new concept in fine motor cars

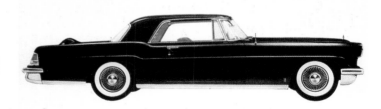

The excitement it stirs in your heart when you see the Continental Mark II lies in the way it has dared to depart from the conventional, the obvious.

And that's as we intended it. For in designing and building this distinguished motor car, we were thinking, especially, of those who admire the beauty of honest, simple lines . . . and of those who most appreciate a car which has been so conscientiously crafted.

The man who owns a Continental Mark II will possess a motor car that is truly distinctive and will keep its distinction for years to come.

Continental
Mark II

Continental Division • Ford Motor Company

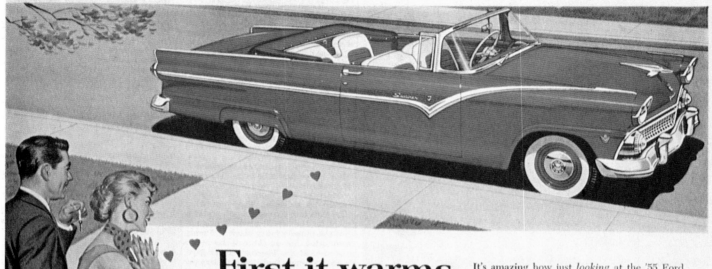

First it warms your heart...

(That Thunderbird Styling!)

It's amazing how just *looking* at the '55 Ford gives so many people that wonderful feeling. Why not? There's "Thunderbird" written in almost every line . . . from the hooded headlights to the flat rear deck. Inside, you'll see exciting color harmonies in durable fabrics. All in all, there isn't a more *pleasing* car in sight.

Then it reads your mind...

(That Trigger-Torque Power!)

Behind the wheel of the new Ford, *you* become a new man. For under your foot lies response so eager and alive, you almost believe it's clairvoyant! This is Ford's Trigger-Torque power . . . and it replies to your driving demands with split-second agility. There's safety in power like this . . . to whizz you out of traffic snarls . . . and to pass you ahead when passing is called for. Three new stout-hearted engines to choose from. And at least a score of other new engineering features. Reading about it is nowhere near the fun of driving the new Ford. So why not visit your dealer today?

Treat yourself to a Trigger-Torque Test Drive in a new

'55 Ford

'55 Ford Convertible

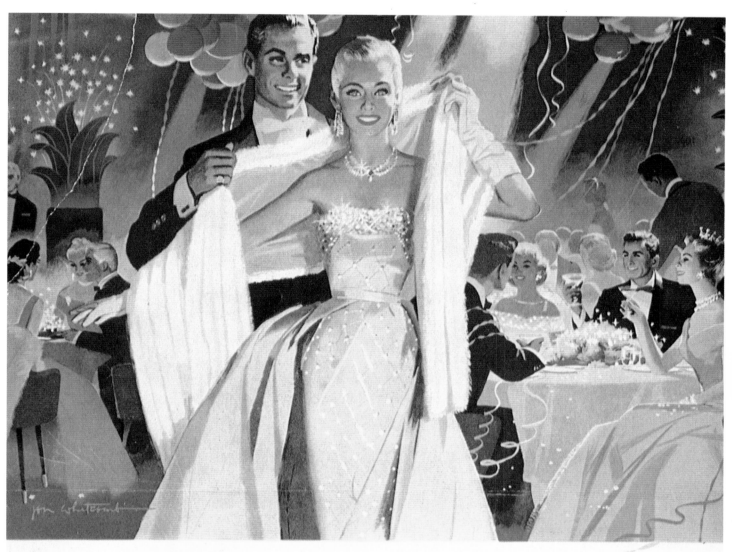

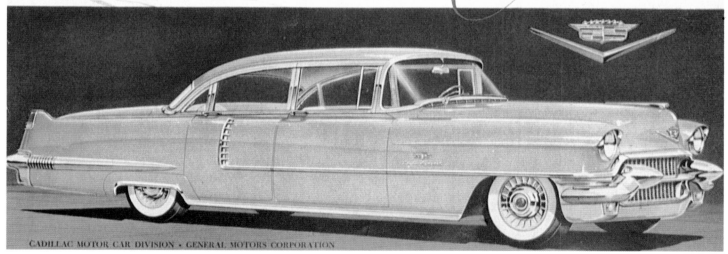

Happy Resolution for a Happy New Year!

Cadillac

'56 Cadillac

Now showing—the happiest "double feature" of the year! One part is bold, new Motoramic styling. The other is record-breaking V8 action.

Hollywood has a heap of words that describe it: colossal, stupendous, magnificent. We'll settle for just the name—Chevrolet.

Because once you've driven this sweet-handling showboat, the adjectives will take care of themselves. Once you've sampled Chevy's hair-trigger reflexes and nailed-down stability, you'll see why it's one of the few great road cars built today!

Horsepower that ranges up to 225 makes hills flatter and saves precious seconds for safer passing. And the way this Chevrolet wheels around tight turns would gladden the heart of a dyed-in-the-wool sports car fan.

See your Chevrolet dealer sometime soon and highway-test this new Chevrolet. . . . Chevrolet Division of General Motors, Detroit 2, Michigan.

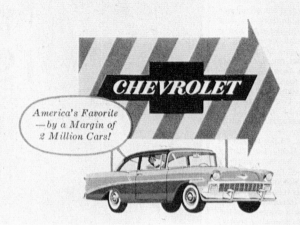

CHEVROLET

America's Favorite —by a Margin of 2 Million Cars!

youth, beauty, Chevrolet, action !

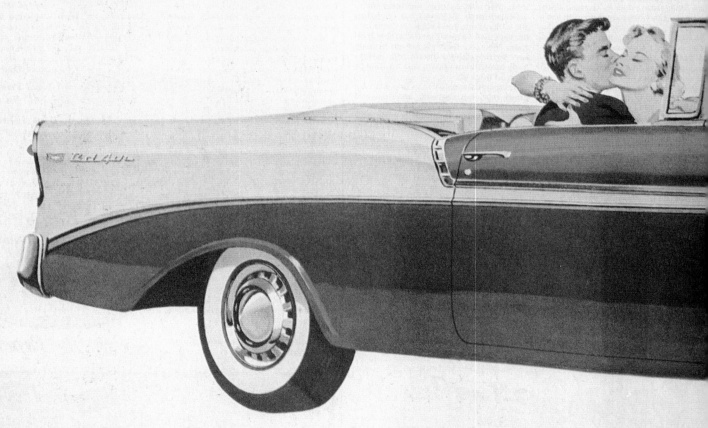

The Bel Air Convertible with Body by Fisher—one of 20 frisky new Chevrolets

'56 Chevrolet

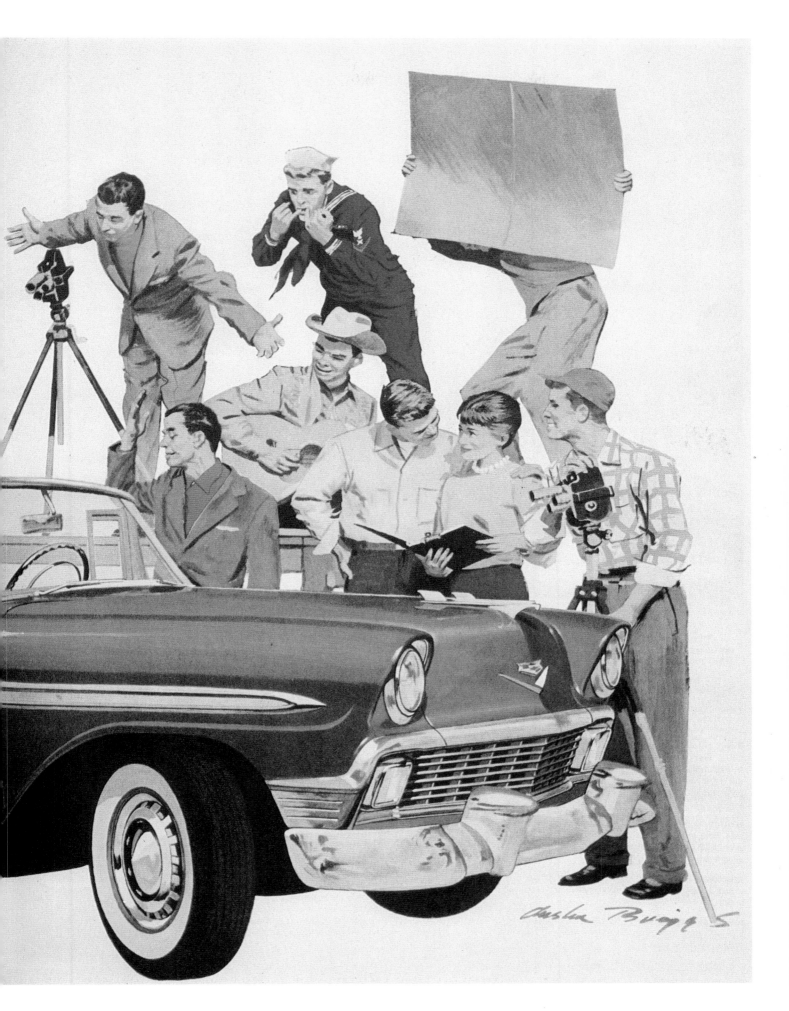

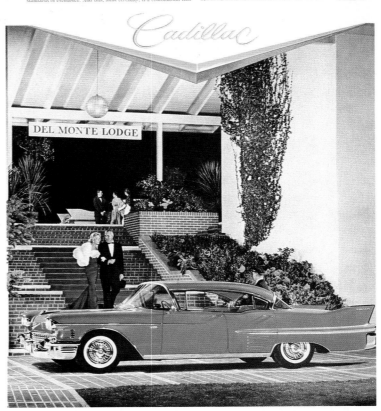

PHOTOGRAPHED IN DISNEYLAND

New Nash Ambassador Country Club with 220 HP Jetfire V-8, Twin Ultramatic Drive, Power Steering, Power Brakes, Power-Lift Windows optional

Make it a Nash Vacation…
in the World's Finest Travel Car!

VACATION in true comfort, safety and style . . . in Nash! For the World's Finest Travel Car has the exclusive features that make any trip—across town or across country—a genuine pleasure.

Here you enjoy the greatest shoulder room ever built into an automobile . . . the widest front seat, the most legroom. Here you enjoy the "finest shockproof ride in the industry." Even Airliner Reclining Seats for perfect relaxation every driving mile and Twin Travel Beds that let you forget lodging worries.

Traditional Nash economy means you save as you drive. And Single Unit Car Construction—the Biggest Difference In Cars Today—affords the greatest protection for you and your family.

Backed by $25,000 Personal Automobile Accident Insurance against fatal injury

When you buy a new Nash, you receive automatically a total of

$25,000 Insurance, divided equally between husband and wife, providing for payment of $12,500 to estate of either—a total of $25,000—if either or both should be fatally injured while driving or riding is their new private passenger Nash anywhere in the world during first year of ownership. Applies only where state insurance laws permit. Here is true backing to support your confidence that Nash, the world's finest travel car, is the safest car you can drive!

Nash for 1956

AMBASSADOR • STATESMAN • RAMBLER • METROPOLITAN

Division of American Motors Corporation, Detroit 32, Michigan

Hurry! Hurry! Still Time To Win!
$$$$$ ¼ MILLION $$$$$
PRIZES FOR NAMES IN THE
BIGGEST CONTEST ON RECORD

SEE THE DIFFERENCE

The statement above represents the finest compliment that could be paid a Cadillac car. Yet, we feel it is a compliment that is richly deserved. With regard to beauty, to performance, to luxury, to craftsmanship and to value—this newest "car of cars" represents a glorious step beyond even Cadillac's own high standards of excellence. And this, most certainly, is a combination that

deserves your personal appraisal. We suggest that you let your dealer introduce you to Cadillac's exclusive Fleetwood coachcrafting—and being you up-to-date on all the new models, including the Eldorado Brougham. You will be his welcome guest at any time.

CADILLAC MOTOR CAR DIVISION • GENERAL MOTORS CORPORATION

Light the Way to Safety—Aim Your Headlights • Every Window of Every Cadillac is Safety Plate Glass

Cadillac

DEL MONTE LODGE

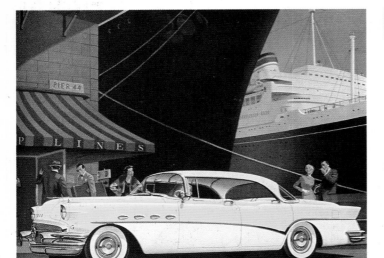

PIER 44

LINES

When better automobiles are built Buick will build them

What's the true measure of a fine car?

Each man, of course, must name his own values.

With automobiles, some men judge fineness by the price they pay—others, by the worth they find therein.

To those who judge fine cars almost on a best-of-breed basis, ROADMASTER is fast becoming a constant choice.

This is in strict keeping with true astuteness—for ROADMASTER is the very cream of the great line of Buicks that have moved to historic sales heights.

Naturally, as the finest measure of these cars, ROADMASTER starts with the many attributes that have won such huge popularity for Buick

automobiles—and climbs to its own pedestal.

Thus, when you slip behind the wheel of this Buick of Buicks, you know fine-car motoring as only soaring success can perfect it.

You know it first as a long, low grace of automobile smartly distinguished by its individualized styling.

You know it next as a harmony of fabric and color—and decorator taste—fully expressive of your fashion modernity.

You know it finally as a suave and spirited and spine-tingling performer.

Buoyant with the ride of all-coil springings and deep-oil cushioning . . .

Responsive with the might of record-high V8 power . . .

Electrifying with the instant response of an advanced new Variable Pitch Dynaflow—the most modern transmission yet brought to the American scene.

ROADMASTER is the name, luxury is the keynote—custom-appointed to your order. And no man who chooses not merely by symbol alone can ask for more, or finer.

We can promise you a rewarding experience if you will accept a ROADMASTER demonstration at your Buick dealer's. See him soon.

BUICK Division of GENERAL MOTORS

ROADMASTER
Custom Built by Buick

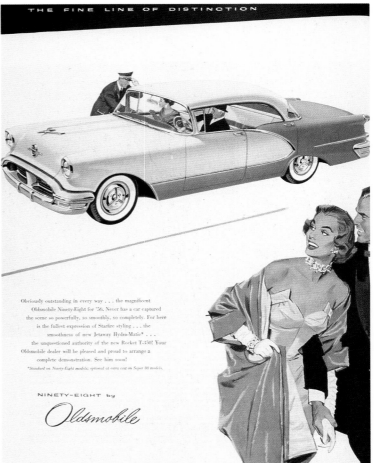

Obviously outstanding in every way . . . the magnificent Oldsmobile Ninety-Eight for '56. Never has a car captured the scene so powerfully, so smoothly, so completely. For here is the fullest expression of Starfire styling . . . the smoothness of new Jetaway Hydra-Matic* . . . the unquestioned authority of the new Rocket T-350! Your Oldsmobile dealer will be pleased and proud to arrange a complete demonstration. See him soon!

Standard on Ninety-Eight models; optional at extra cost on Super 88 models.

NINETY-EIGHT by

Oldsmobile

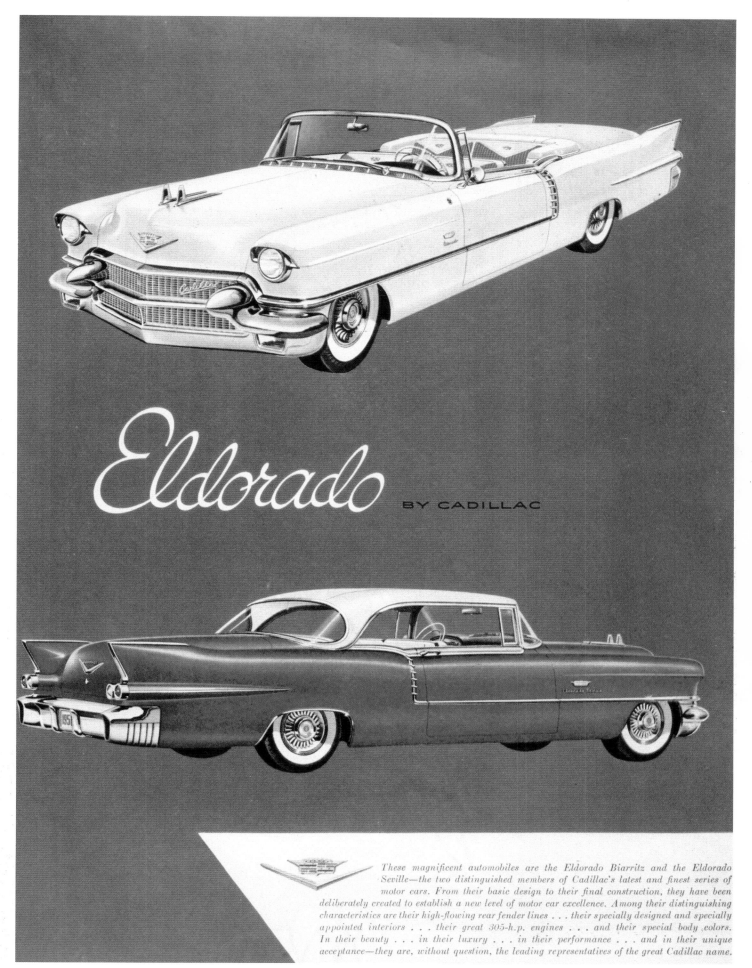

Eldorado

BY CADILLAC

These magnificent automobiles are the Eldorado Biarritz and the Eldorado Seville—the two distinguished members of Cadillac's latest and finest series of motor cars. From their basic design to their final construction, they have been deliberately created to establish a new level of motor car excellence. Among their distinguishing characteristics are their high-flowing rear fender lines . . . their specially designed and specially appointed interiors . . . their great 305-h.p. engines . . . and their special body colors. In their beauty . . . in their luxury . . . in their performance . . . and in their unique acceptance—they are, without question, the leading representatives of the great Cadillac name.

'56 Cadillac Eldorado

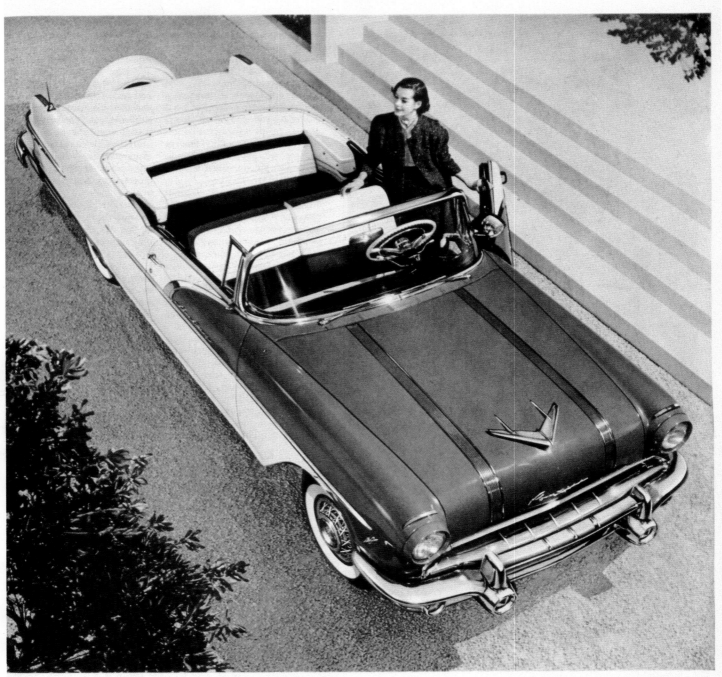

presenting the

STAR CHIEF *Custom Convertible*

A Very Special Car for a Very Special Person!

If you think this long, low creation is America's *handsomest* car, you'll find plenty of support among connoisseurs of such things.

But performance is its forte . . . breath-taking performance that quite literally creates for this great car a class all its own! Cradled under that sleek hoodline is the most advanced power plant of them all, the brilliant 227 h.p. Strato-Streak V-8 (12 more horsepower with low extra-cost dual exhausts)!

And Pontiac's revolutionary oil-smooth Strato-Flight Hydra-Matic* completes the most thrilling power team ever to hit the highway.

For those who demand the first word in *glamour* and the last word in *go*—here is the car you've been waiting for—the magnificent Star Chief Custom Convertible by Pontiac. *An extra-cost option*

PONTIAC

PONTIAC MOTOR DIVISION OF GENERAL MOTORS CORPORATION

HOLIDAY/MAY

'56 Pontiac

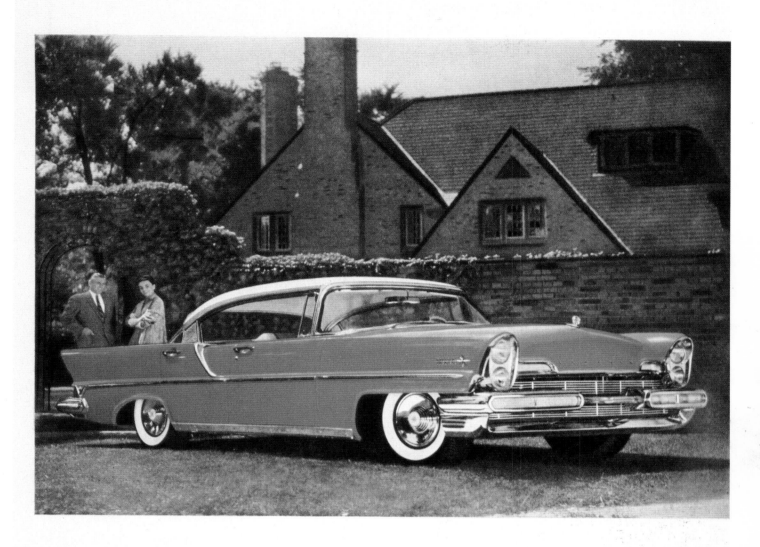

Presenting the dramatically new
LINCOLN FOR 1957

UNMISTAKABLY...THE FINEST IN THE FINE CAR FIELD

Dramatic New Styling Everywhere! From the unmistakable newness of Quadra-Lite Grille to the sweep of canted rear blades, here is the longest, lowest, most *distinctive* Lincoln of all time. Wherever you look—inside and out—you discover bold new ideas in fine car design.

Powerfully New In Fine Car Performance! Behind the wheel, you discover a new kind of swift, silken 300 horsepower in the most powerful Lincoln ever built . . . a new kind of fast-action, Turbo-Drive automatic transmission . . .

a new kind of Hydro-Cushioned ride! Here, you know instantly, is a whole new standard of what fine cars should be and do.

And More . . . Lincoln's new array of power luxuries makes this the most *effortless* driving fine car ever built. Everything you touch turns to power! Electric door locks, 6-way power seats, power window vents, power lubrication . . . these are but a few of the automatic luxuries offered in this Lincoln. Why don't *you* see . . . and drive . . . Lincoln for 1957 *now*.

'57 Lincoln

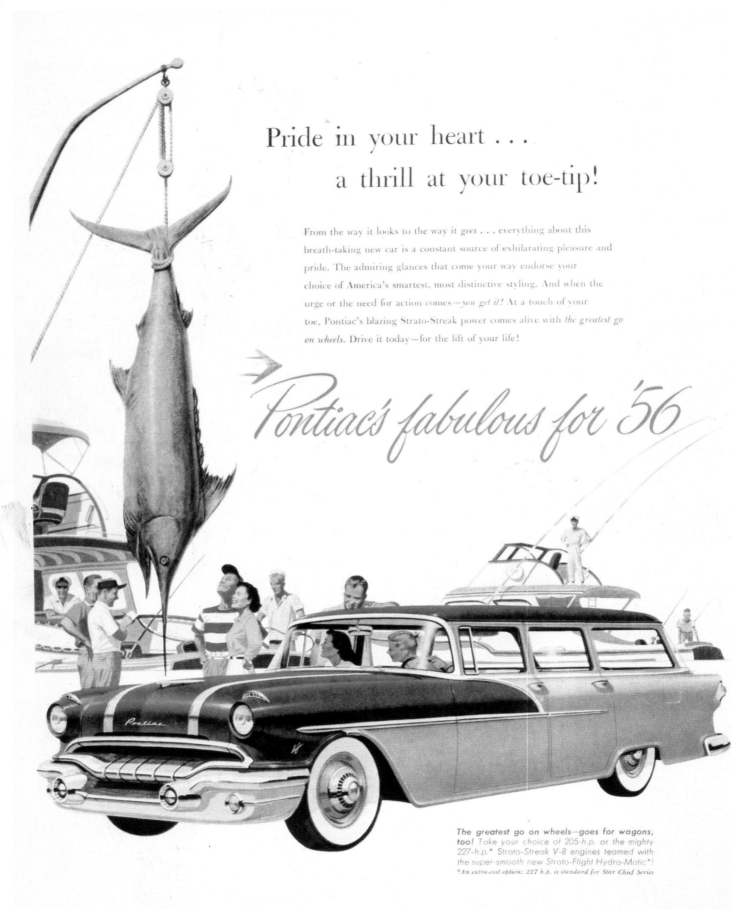

Pride in your heart . . .
a thrill at your toe-tip!

From the way it looks to the way it *goes* . . . everything about this
breath-taking new car is a constant source of exhilarating pleasure and
pride. The admiring glances that come your way endorse your
choice of America's smartest, most distinctive styling. And when the
urge or the need for action comes—*you get it!* At a touch of your
toe, Pontiac's blazing Strato-Streak power comes alive with *the greatest go
on wheels.* Drive it today—for the lift of your life!

Pontiac's fabulous for '56

**The greatest go on wheels—goes for wagons,
too!** Take your choice of 205-h.p. or the mighty
227-h.p.* Strato-Streak V-8 engines teamed with
the super-smooth new Strato-Flight Hydra-Matic*!
An extra-cost option; 227 h.p. is standard for Star Chief Series

PONTIAC MOTOR DIVISION OF GENERAL MOTORS CORPORATION

MORE PEOPLE NAMED JONES*
OWN CHEVROLETS THAN ANY OTHER CAR!

(Are you keeping up with the Joneses?)

*Of course we haven't actually counted all the Joneses. But it seems a safe guess. Because this year—as they have year after year—more people are buying Chevrolets. And 2 million more people drive Chevrolets than any other car. Maybe you ought to stop by your Chevrolet dealer's and see why this is so.... Chevrolet Division of General Motors, Detroit 2, Michigan.

CHEVROLET

America's largest selling car— 2 million more on the road

'56 Chevrolet

Presenting...
an altogether new series
of fine cars

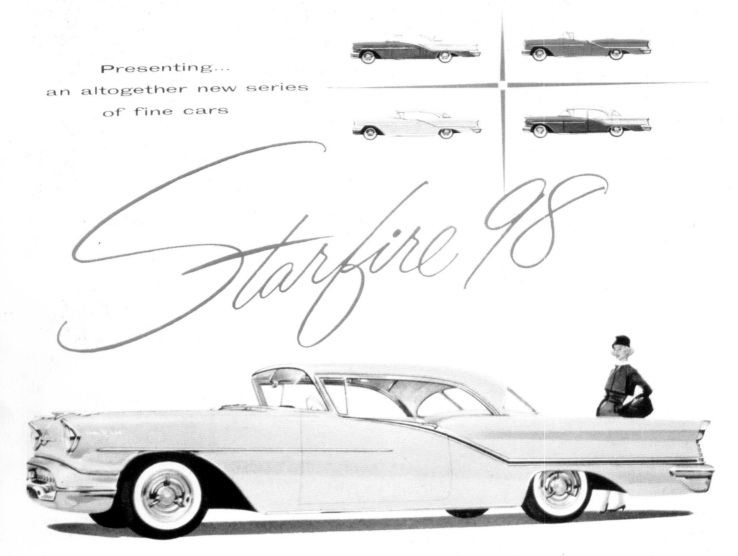

Starfire 98

...WITH THE ACCENT ON LUXURY!

Here, luxuriously yours, is the splendid new Starfire
98 . . . the finest expression of Oldsmobile distinction
and engineering leadership. Here is the alert perform-
ance of the great new 277-h.p. Rocket T-400 Engine
. . . the smooth-riding qualities of Oldsmobile's Wide-
Stance Chassis . . . the stunning styling of the newest
"low-level" look. Your Oldsmobile Quality Dealer
invites you to inspect these magnificent new
Starfire 98 models at your earliest opportunity.

OLDSMOBILE
THE CAR THAT PUTS
THE ACCENT ON *YOU!*

Glamorously new inside, too!
And all models are fully equipped
with Jetaway Hydra-Matic, Power
Steering and Power Brakes.

'57 Oldsmobile

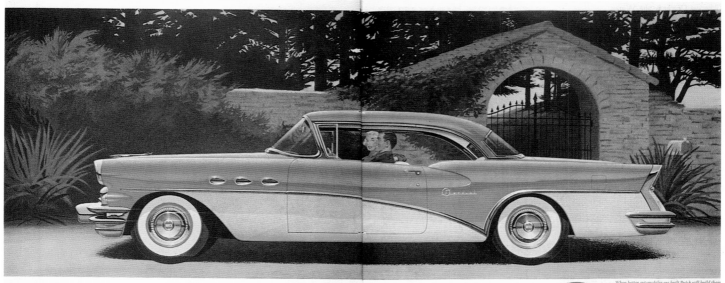

When better automobiles are built Buick will build them

Just one Big Thrill fromend to end

LET'S SAY you've just taken your first drive in a '56 Buick—and you're telling the story.

Where would you start? With that new Variable Pitch Dynaflow*?

Fair enough—for *that* brings a new thrill no other car can even come close to.

How did it feel when you pressed that pedal and found yourself taking off in a single, smooth and unbroken sweep—with no lag between standstill and go—no gear-to-gear "bump" as you moved up to cruising pace?

Did you get a kick out of gliding through traffic like a skier on slopes?

Were you thrilled as you rolled the highway at only part throttle —where folks do most of their driving—and where Dynaflow brings you its biggest boost in gas mileage?

And did you feel a joyous satisfaction when you switched the pitch for Dynaflow's all-out surge of full power to pull you safely out of a tight spot on the highway?

But wait. How about all those other new Buick lifts?

How about the fun of bossing Buick's big, new, walloping 322-cubic-inch V8 engine—now lofted to new highs in power and compression . . .

The honey-comfort of Buick's great new ride—now made even sweeter and more buoyant by new deep-oil shock-absorber cushioning added to Buick's famed all-coil springing . . .

The bliss and bounty of Buick's new handling ease—and new road steadiness—and new Safety Power Steering!—and new luxury of fabrics, appointments and colors . . .

The happy thrill of knowing you can get all these Buick blessings at a satisfying price—all the way from the thrifty,

bedrock-priced SPECIAL, to the fast-stepping CENTURY, to the spirited SUPER—and on to the custom-built ROADMASTER.

Looks like we've told the story, after all.

But *your* time is coming—if you'll just go take your ride and make your deal, at your Buick dealer's. See him this week, for sure.

BUICK Division of GENERAL MOTORS

See Jackie Gleason on TV every Saturday Evening

AT A NEW LOW PRICE—*4-Season Comfort* in your new Buick with FRIGIDAIRE CONDITIONING

Best Buick yet

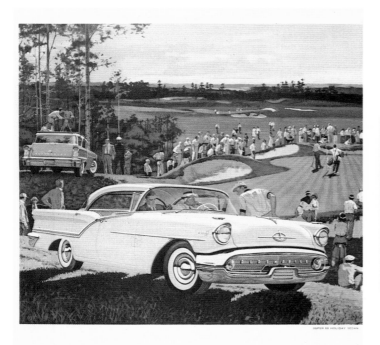

SUPER 88 HOLIDAY SEDAN

Check the Score... AND YOU'LL GO OVER TO OLDS!

You're in for a whole series of pleasant surprises when you first check the score on Olds ownership.

Very likely, you'll find the price less than you imagined —most people do! And when it comes to value, it's great to see how much more Oldsmobile offers for your every dollar. *Performance* values in the Rocket Engine. *Engineering* values that spell greater comfort, safety and driving ease. *Styling* values, inside and out,

that mean you'll drive your Oldsmobile with pride. And most important, *lasting value* . . . that holds a real pay-off for you at resale time!

Talk it over with your Oldsmobile dealer. He'll show you that *there's a Rocket for every pocket* . . . and that this is the right time to make that wonderful move to Olds!

OLDSMOBILE DIVISION, GENERAL MOTORS CORPORATION

OLDSMOBILE

SEE YOUR AUTHORIZED OLDSMOBILE QUALITY DEALER

Want the **Big** buy for **Big** families?

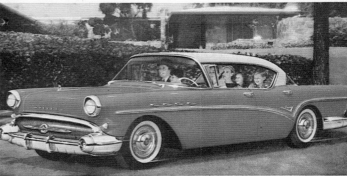

Step into the Super— it's the dream car to drive!

Now step out in room—big-car room—SUPER room—room and to spare for the whole blessed crew of you.

Room for your arms, shoulders, heads, hats—most especially for your legs and your *feet*.

Room that is virtually astonishing—and that's no exaggeration—in a car so low and sleek, so slim and compact, so miraculously maneuverable in traffic, so *instant* in its response.

Above all, room that even stretches your dollars. That makes this car your biggest buy today. *That simply can't be surpassed in cars costing up to $1,500 more than the '57 Buick SUPER.*

Go see for yourself. See the grace and space—sample the pace—of this big, best-buy '57 Buick SUPER. Do it now, with the best of weather still ahead of you. Visit your Buick dealer *today*.

BUICK Division of GENERAL MOTORS

Most completely changed Buick in history

Only when you get in and drive it can you know how true this statement is:

This '57 Buick is new from top to bottom, and newest where it counts most—in performance.

For here's an all-new V8 engine with the "power-pack" built in at no extra cost.

Here's an utterly instant new Variable Pitch Dynaflow.

Here's a new deep-nested ride—new kind of ball-joint steering—powerful new straight-line *levelized* braking— ingenious new Safety-Buzzer* that helps you drive more safely—vast new super-panoramic windshield—more new features than we can mention.

But they all add up to one overwhelming conclusion that we'd like to prove for yourself—

Here is America's dream car *to drive*. Discover that in the doing—at your Buick dealer's—today!

When better automobiles are built Buick will build them

Big thrills **Buick**

SPECIAL · CENTURY · SUPER · ROADMASTER — and ROADMASTER 75

New Advanced Variable Pitch Dynaflow is the only Dynaflow Buick builds today. It is standard on Roadmaster, Super and Century—optional at modest extra cost on the Special. Safety-Buzzer is standard on Roadmaster, optional other Series.

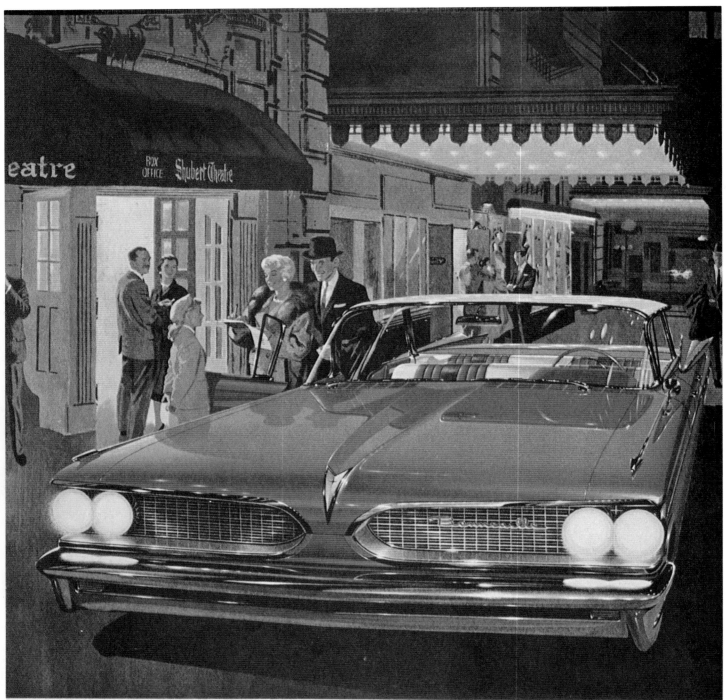

You get the solid quality of Body by Fisher.

Sparkling showcase for the year's hottest advances!

It would be a hit on its looks alone!

But there's so much more beneath Pontiac's crisply sculptured styling that it's nothing short of sensational.

For one, the wonderful roadability and ride of exclusive Wide-Track Wheels, which have won the acclaim of car experts as the year's top engineering advance.

For another, its choice of the industry's two most advanced V-8's: the Tempest 420 for the ultimate in

easygoing response and its companion, the Tempest 420E, which made V-8 history by setting a NASCAR supervised coast-to-coast economy mark on regular gas—*only 1½¢ per mile!*

You could go on and on with the many engineering wonders Pontiac alone provides. But the best evidence is a test drive. Why not take one soon?

PONTIAC MOTOR DIVISION · GENERAL MOTORS CORPORATION

PONTIAC! America's Number ① Road Car!

3 Totally New Series · Catalina · Star Chief · Bonneville

ONLY CAR WITH *WIDE-TRACK* WHEELS!

. . . acclaimed by experts as the year's top engineering advance! The wheels are moved out 5 inches for the widest, steadiest stance in America—lower center of gravity for better grip on the road, safer cornering, smoother ride, easier handling. *Pontiac gives you roadability no narrow gauge car can offer!*

See Phil Silvers on Pontiac Star Parade, Jan. 23—CBS-TV

'59 Pontiac

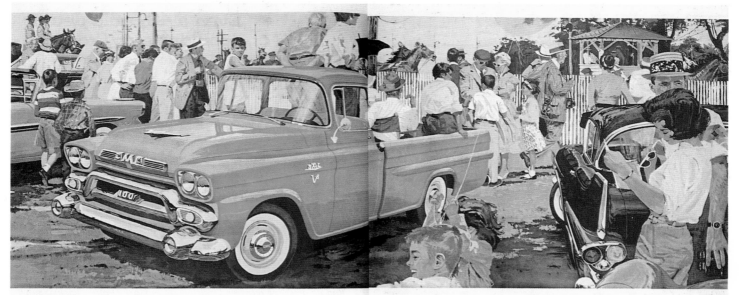

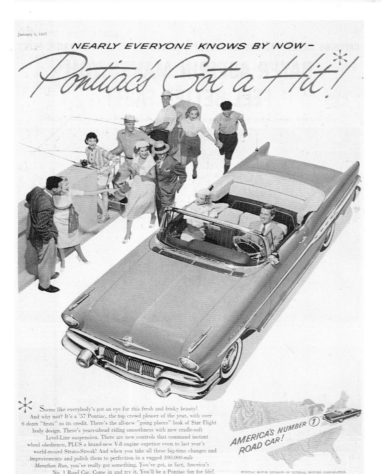
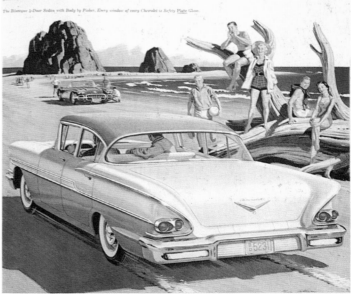

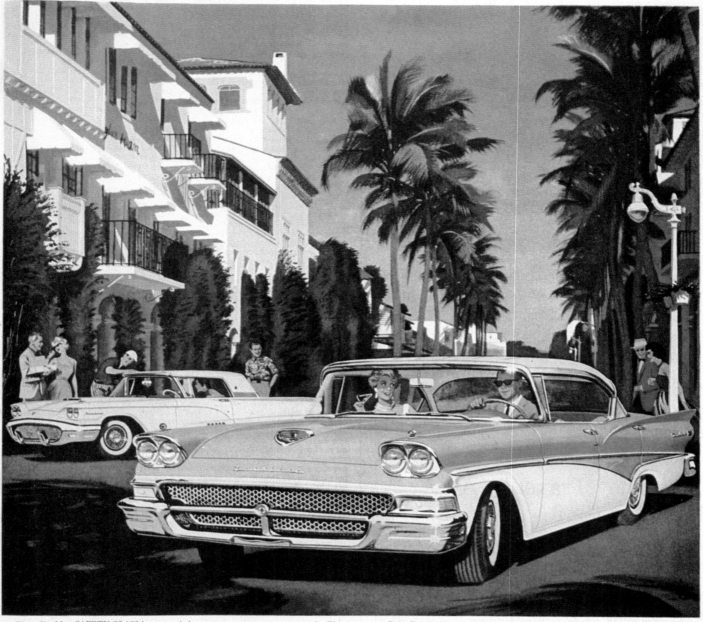

Every Ford has SAFETY GLASS in every window

On Worth Avenue, Palm Beach, Florida, the Ford Fairlane 500 Town Victoria . . . one of 21 new models in which you can enjoy Cruise-O-Matic Drive. In background, *the new 4-passenger Thunderbird . . . another Cruise-O-Matic Ford that inspired the styling and performance for all 1958 Fords.*

Try the Thunderbird magic of a Cruise-O-Matic Ford

It gives you the smoothest, most automatic driving and turns Thunderbird "go" into gas savings, too!

Long highway haul? It was never so easy! City traffic? *Never* before so effortless! An especially steep hill? A car to pass? Cruise-O-Matic Drive glides into whichever gear is best for *any* driving situation, briskly . . . automatically! And a fluid torque converter keeps these automatic shifts a smooth, silent secret.

Want smooth, sure-footed starts on sand, mud, ice or snow? Shift from D-1 range, where all normal driving's done, to new D-2. This is the Thunderbird's own automatic drive . . . and you can team it with the T-bird's own V-8 power in any Ford. Together they save up to 15 cents on every gas dollar. That's because of versatile Cruise-O-Matic's exclusive built-in overdrive feature and the Thunderbird V-8's "thrust-boosting," gas-saving Precision Fuel Induction.

And the best news of all . . . No one offers such a premium-performing automatic drive for so little. Come discover Ford's automatic Thunderbird magic for yourself.

58 Nothing newer in the world

F●RD

'58 Ford

THUNDERBIRD

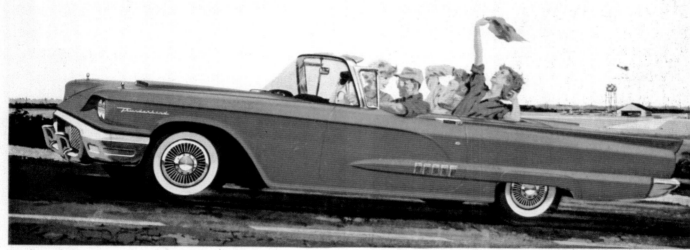

Thunderbird—the most wanted, most admired car in Amer

Another first from Ford — the incomparably exciting new Thunderbird <u>Convertible</u>!

Two magnificent engines—the standard 300-hp and the new, optional 375-hp—make this the greatest performer you've ever handled—bar none!

You've driven this new 4-passenger Thunderbird convertible many times —in your dreams.

Now it's really here—and, as you can see, several light-years ahead of anything else on the road.

For when you take this compact jewel of a car and power it with Thunderbird's magnificent 300-horsepower V-8 engine, you get brilliant performance, of course. Power it with Thunderbird's new 375-horsepower V-8 and you get performance that's nothing short of spectacular.

Acceleration? Merely wonderful. Hills?

What hills? Curves? You'll take 'em like a dream! And, by any standards, the new T-bird is eminently safer in design, in build, in action. Practical, too. You can glide this 4-passenger beauty into places the big cars have to pass up.

All this—and more—for *four* fortunate people, who can share the Thunderbird thrills in deep, individually contoured, lap-of-luxury seats.

To get the details—particularly about Thunderbird's price, which is *far* below that of other luxury cars—see your Ford Dealer soon.

Thunderbird's new hide-away soft top is tastefully color-keyed, disappears completely into the spacious trunk. Top down, the distinctively sculptured rear deck is perfectly flush with the rear seats, forming one smooth, uninterrupted line of Thunderbird beauty!

Every Ford has SAFETY GLASS in every window

AMERICA'S MOST INDIVIDUAL CAR

HOLIDAY/AUGUST

'58 Thunderbird

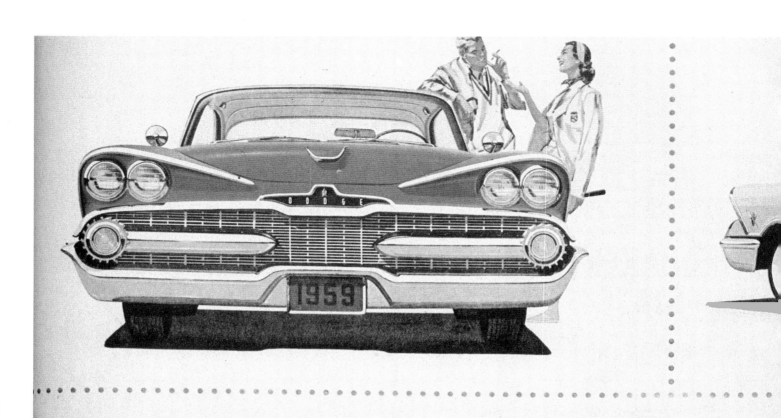

SO MUCH THAT'S NEW! SO MUCH T

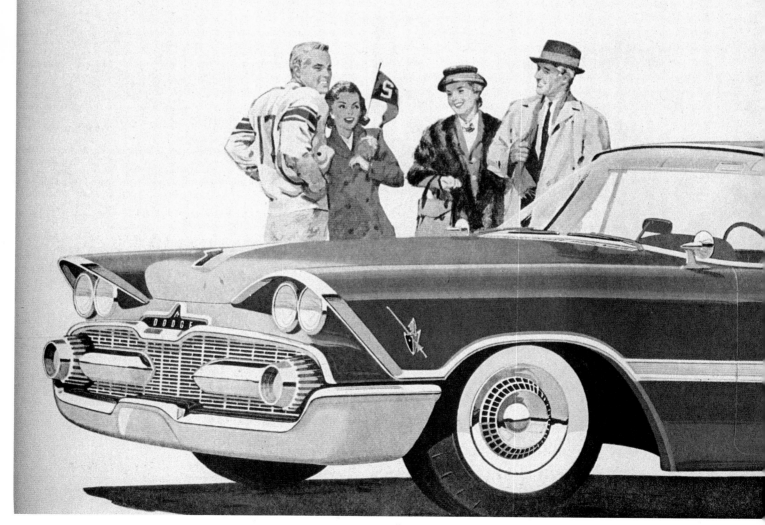

'59 Dodge

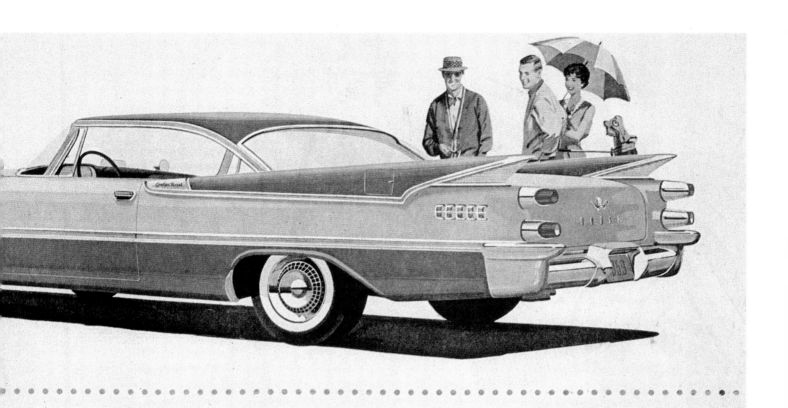

GREAT ! SO MUCH THAT'S DODGE !

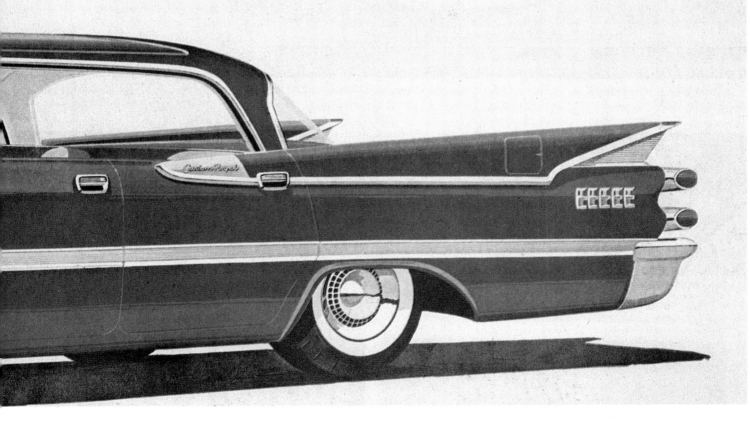

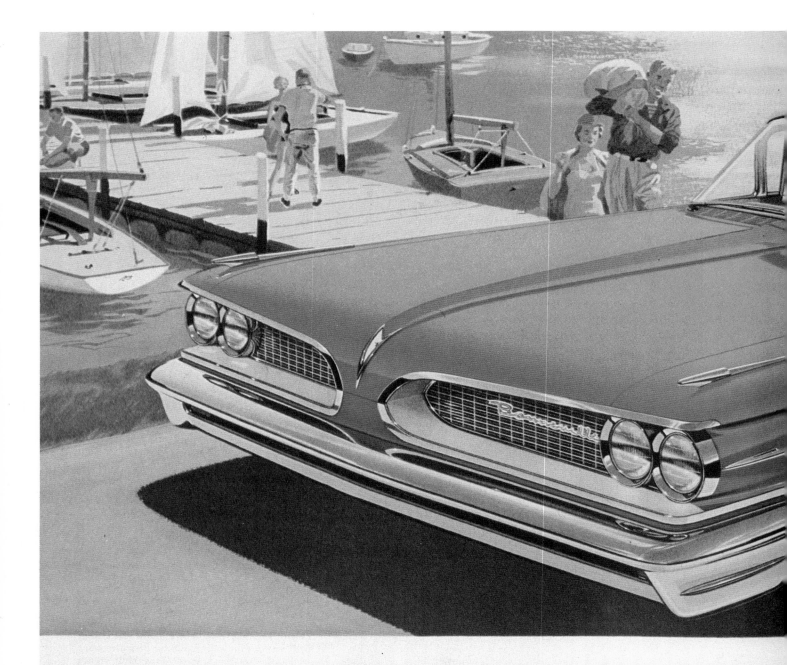

Trim...Tailored...Terrific...and America's Num

If you like your action taut—and sheathed in clean, crisp lines—Pontiac '59 is the one car that wraps up everything you want on the grandest, most glorious scale you've ever known!

It starts with wide-track wheels for unsurpassed road-hugging stability—and a new, low look no narrow gauge car can hope to imitate. Beneath the glamour you'll find all the best of the new ideas: Air-Cooled True-Contour Brakes for safer stops, unvarying control ... vista-lounge interiors with full 360-degree visibility and seats *wider than a sofa* ... Vista-Panoramic windshield that curves up into the roof ... long-lasting

Magic-Mirror finish that keeps its new-car luster up to five times longer—the most durable car finish known.

In the performance department, the industry's most modern power plant reaches new perfection in the Tempest 420 V-8, so free of vibration and sound you almost forget it's there. *And there's an amazing new economy engine, optional at no extra cost, that gives you V-8 muscle with the extra mileage of a much smaller engine—and performs its miracles on regular gas!*

But that's only part of the story. Come in and discover *all* the big and wonderful things that have happened to America's Number One Road Car!

PONTIAC MOTOR DIVISION • GENERAL MOTORS CORPORATION

'59 Pontiac

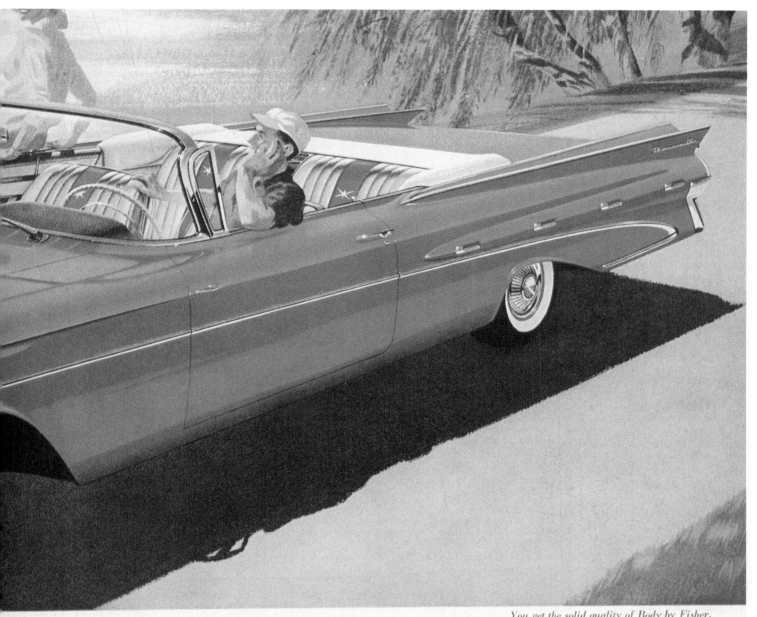

You get the solid quality of Body by Fisher.

Road Car!

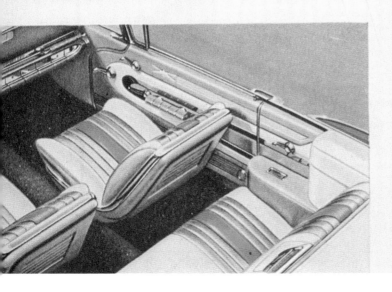

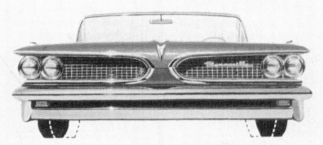

EXCLUSIVELY YOURS—*WIDE-TRACK* WHEELS

The wheels are moved out 5 inches for the widest, steadiest stance in America—better cooling for engine and brakes, far better grip on the road, safer cornering, smoother ride, easier handling. *You get the most beautiful roadability you've ever known—in America's Number ① Road Car!*

PONTIAC!

The Newest of Everything Great! — The Greatest of Everything New!

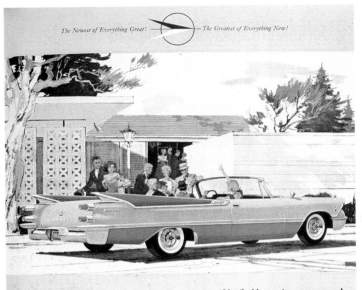

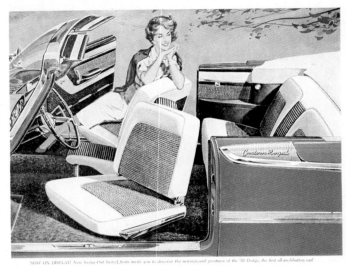

Don't look now, but they're all following you!

Your new 1959 Dodge stands waiting in the drive: Sleek and clean and lovely.

You swing into it (via new swivel seats!), close the door and start the engine.

Now look around you. There are other '59 cars parked nearby. Friends of yours are getting into them.

But you and your new Dodge are definitely the leaders, the pace setters, in your group—ahead in every department.

You are out in front in styling, with the low, crisp Swept-Wing lines that the other 1959 cars seek to copy.

You establish the trend with the taut "look of motion" that other cars are patterned after: The swift sweep of fins, the forward thrust of fenders over dual headlamps, the curving arch of compound windshield.

You blaze the trail of engineering leadership with the incomparable stability of Torsion-Aire ride, the sure mastery of push-button driving, the thrust of your more efficient engine.

They're all following you! One sure reward for owning a new '59 Dodge!

'59 **DODGE**

NOW ON DISPLAY! New Swing-Out Seats! Seats invite you to discover the newness and greatness of the '59 Dodge, the first all-pushbutton car!

The Newest of Everything Great!

The Greatest of Everything New! New things, great things, reward you in this '59 Dodge. Seats swing out to meet you in. New HC-HE engines deliver more thrust, use less gas. New Level-Flite Torsion-Aire introduces you to three dimensional comfort—ride control, road control, load control. Outside mirrors adjust from the inside. Inside mirrors adjust themselves electronically. But the final reward is the deep-down greatness built into this '59 Dodge. See and drive it today.

New '59 DODGE

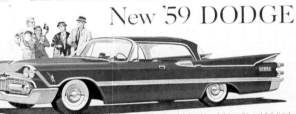

So much that's new! So much that's great! So much that's Dodge!

HOLIDAY/NOVEMBER

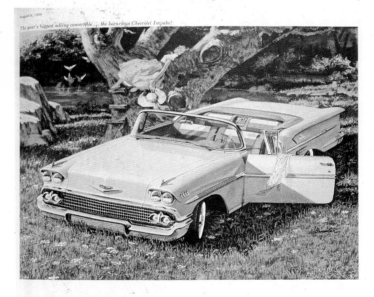

August 9, 1958

The year's biggest selling convertible ... the luxurious Chevrolet Impala!

SERENITY... BY DESIGN! *A car is more than just the sum of good engineering. Here, in the new* **CHEVROLET,** *superlative design has created a new dimension ... a harmony of behavior, a serene personality that glorifies every mile you travel.*

Chevrolet design merely *begins* with the marvelous ingenuity of Full Coil suspension, the advanced power of Turbo-Tread V8's,* the low-slung heft of Safety-Girder frame. For these are just building blocks—the rest is endless hours of testing, perfecting, refining.

This devotion to balance in design is one of the major reasons why Chevrolet has been the most successful car the world has ever seen. It is the real reason behind the solid satisfaction of Body by Fisher—the day-after-day pleasure of doors that close with a smooth "click," the really thorough sound-proofing that limits up tiring vibration, the enduring elegance of substantial hardware, of upholstery fabrics that last and last.

It is the reason why Chevy's steering is so true-running, why its roadability is world-famous, why its balance and stability leave you so remarkably refreshed after a long day's journey. This emphasis on perfection is also the basic reason why Chevrolet's engines purr out such silken power, so thriftily and for so many thousand miles.

This multitude of details all adds up to one big thing: a serenity of motion, a balance of design that is unduplicated. Why not experience it? Your Chevrolet dealer has a car waiting. . . . *Chevrolet Division of General Motors, Detroit 2, Michigan.*

*Optional at extra cost.

CHEVROLET

THE SATURDAY EVENING POST

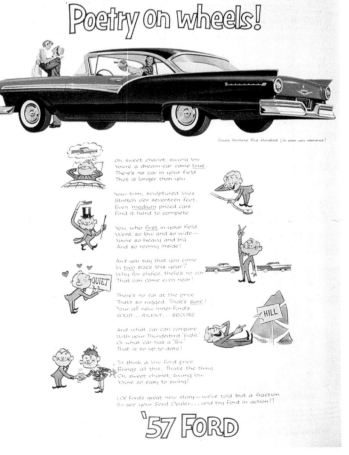

Poetry on wheels!

Ford's Fairlane Five Hundred (in case you wondered)

Oh, sweet chariot, swing low
You're a dream-car come *true.*
There's no car in your field
That is longer than you.

Your trim, sculptured lines
Stretch o'er seventeen feet.
Even *medium* priced cars
Find it hard to compete.

You, who *first* in your field
Went so low and so wide—
You're so heavy and big
And so roomy inside!

And you say that you come
In *two* sizes this year?
Why for choice, there's no car
That can come even near!

There's no car at the price
That's so rugged. That's *sure!*
Your all new Inner Ford's
SOLID... SILENT... SECURE.

And what car can compare
With your Thunderbird 'Eight'
Or what car has a 'Six'
That is so up-to-date!

To think a low Ford price
Brings all this . . . That's the thing.
Oh, sweet chariot, swing low
You're so easy to swing!

(Of Ford's great new story—we've told but a fraction
So see your Ford Dealer... and try Ford in action!)

'57 **FORD**

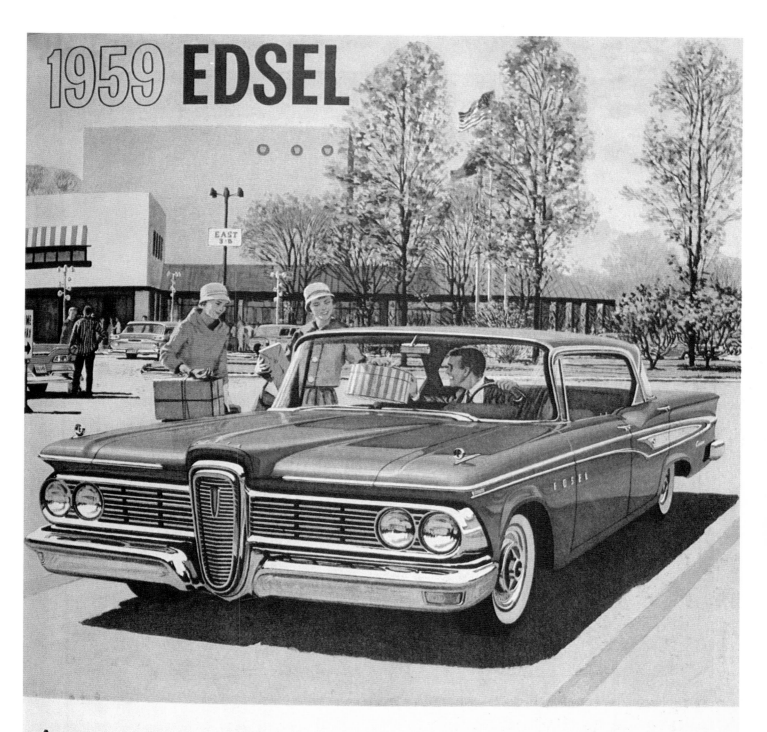

1959 EDSEL

An exciting new kind of car!

Makes history by making sense

Here's the car you hoped would happen. A full-size car that makes sense. Styled to last. Built to last. Beautifully efficient. And priced with the most popular three!

At last—a full-size car that makes sense. It looks right, works right. And it's priced right. The beautifully efficient Edsel for '59 is a car that slips easily into tight parking spaces—fits any normal garage. Same spacious room inside as before—*but less length outside!* It's a car that's powered to save. Edsel's four new engines include not only a thrifty six but a new economy V-8 that turns *regular* gas into spirited performance! It's a car that's distinctively styled to last. And carefully built to last. *Yet, the Edsel is actually priced with the most popular three!* See your Edsel Dealer.

EDSEL DIVISION · FORD MOTOR COMPANY

'59 Edsel

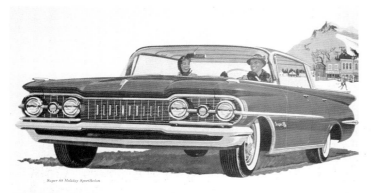

Super 88 Holiday SportSedan

Come see how new driving can be . . . at the wheel of a '59 Olds! Revel in *spaciousness* . . . these are the roomiest Rockets ever! Try the *quiet power* of a smooth, new Rocket Engine . . . the *extra safety* of Air-Scoop Brakes on all four wheels. Relax in the *comfort* of the new "Glide" Ride . . . rakishly styled in Oldsmobile's exciting "Linear Look." Everything about these '59 Oldsmobiles is an invitation to come in . . . get *That Olds Feeling!* ➤ OLDSMOBILE

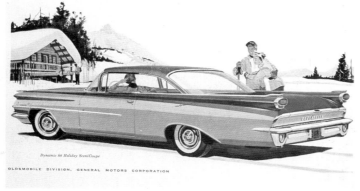

Dynamic 88 Holiday SceniCoupe

OLDSMOBILE DIVISION, GENERAL MOTORS CORPORATION

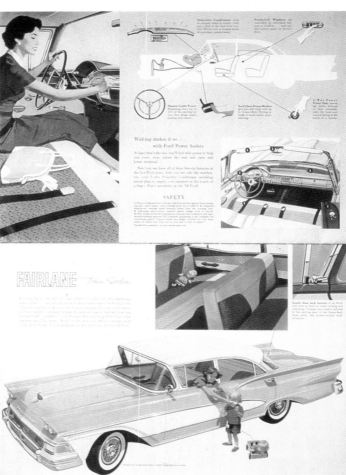

FAIRLANE Town Sedan

THE WORLD-WIDE FORD COMPANIES
present a brilliant new version of a great classic . . .
THE 4-PASSENGER
THUNDERBIRD

Another first from Ford — a jewel of a car — pure Thunderbird in design, spirit and performance . . . with full fine-car room, comfort and luxury for four.

• In the 1958 Thunderbird, Ford has created a wholly new size and type of fine car. It gives you compactness, low road-hugging good looks. It handles and parks like a dream.

Yet — miraculously — it gives you leg room and head room for four large men. Exceptionally wide doors allow you to step in or out with ease and grace.

And now — the all-new Thunderbird V-8 Engine gives you even livelier response and performance. Drive the new 4-passenger Thunderbird soon.

Thunderbird 58 gives you full fine-car room for four people — with interior appointments that are unbelievably imaginative and luxurious.

Thunderbird's unitized body treats extra space . . . gives more comfortable seating. Top, body and frame are all welded into one single piece of sculptured steel.

The silhouette is low, the graceful lines are distinctively long and crisp. Yet Thunderbird provides luxurious head, shoulder and leg room on all four seats.

THE WORLD-WIDE
FORD
COMPANIES

Wherever you live . . . you get more for your money in any Ford-built product
Ford-built products include cars, trucks, tractors, industrial engines, genuine replacement parts: Meteor / Popular · Anglia · Prefect · Consul · Zephyr · Zodiac · Thames · Fordson Major Tractor / Taunus · FK Truck · Continental Mark III · Lincoln · Mercury · Ford · Thunderbird · Edsel · Ford Tractor and Implements

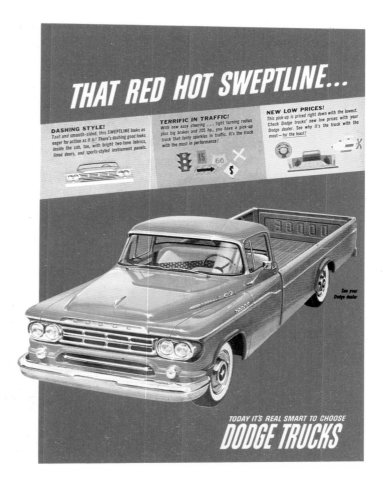

THAT RED HOT SWEPTLINE...

DASHING STYLE!
Taut and smooth-sided, this SWEPTLINE looks as eager for action as it is! There's dashing good looks inside the cab, too, with bright two-tone fabrics, lined doors, and sports-styled instrument panels.

TERRIFIC IN TRAFFIC!
With new easy steering . . . tight turning radius plus big brakes and 205 hp, you have a pick-up truck that fairly sparkles in traffic. It's the truck with the most in performance!

NEW LOW PRICES!
This pick-up is priced right down with the lowest. Check Dodge trucks' new low prices with your Dodge dealer. See why it's the truck with the most — for the least!

See your Dodge dealer

TODAY IT'S REAL SMART TO CHOOSE
DODGE TRUCKS

JUST LOOK AT THE PLYMOUTH FEATURES
THE OTHER LOW-PRICE CARS DON'T HAVE...YET!

SWIVEL FRONT SEATS (standard on Sport Fury models) make getting in and out easier. A wide armrest pulls down between the seats when two ride in front instead of three.

PUSH-BUTTON CONTROL CENTER groups instruments in plain sight, controls in easy reach. Pushbuttons on left control automatic shift*. On right of the wheel: Push-Button Heater and Defroster*.

REAR SPORT DECK (standard on Sport Fury models) is one of the many features that give the low-price '59 Plymouth such a high-price appearance. No other car looks so refreshingly youthful — nor runs so nimbly!

MIRROR-MATIC rear-view mirror* eases tensions of night-time driving by electronically dimming the glare from headlights of the cars behind you.

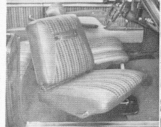
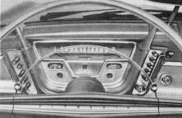

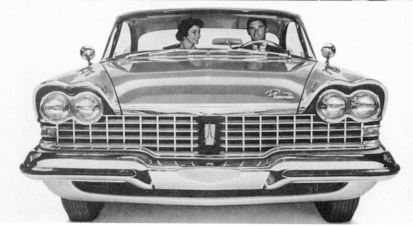

These are only a few of the many new convenience, safety and performance features you'll find on the '59 Plymouth. Don't look for them on any other low-price car ... *only Plymouth offers them.* Before you buy *any* '59 car, see Plymouth. It's exactly what you've always wanted! Let your Plymouth dealer prove it—soon.

** Optional at low extra cost.*

Plymouth
today's best buy, tomorrow's best trade

➤ Introducing NEW SWEPT·WING 58
(So advanced it leaves the rest behind!)

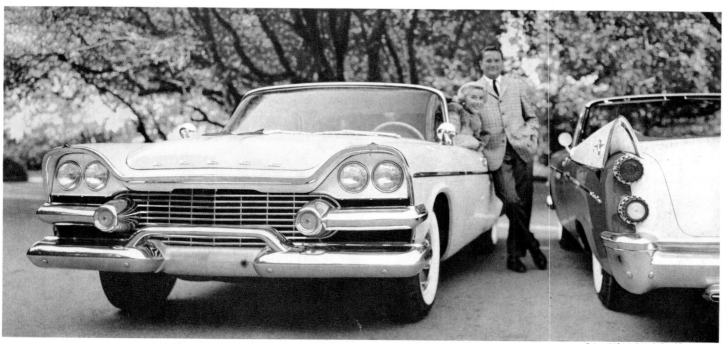

Costumes by Bonnie Cashin for Philip Sills

A MOST UNUSUAL NEW CAR is on display for the first time. It is very low, very daring, beautifully proportioned. "Swept-Wing 58" is the successor to the 1957 Swept-Wing Dodge which launched a "buying revolution" against the high, boxy design. Significant advances include an Electronic Fuel Injection Engine, a new Constant-Control power steering system, a "Sure-Grip" differential for better traction on snow and ice, and a vast new "picture window" windshield which curves up, back and around. To own a Swept-Wing 58 is a new adventure.

SWEPT-WING 58 *by* DODGE

The new 1959 Cadillac car speaks so eloquently—in so many ways—of the man who sits at its wheel. Simply because it *is* a Cadillac, for instance, it indicates his high level of personal achievement. Because it is so beautiful and so majestic, it bespeaks his fine sense of taste and his uncompromising standards. Because it is so luxurious and so regally appointed, it reveals his consideration for the comfort of his fellow passengers. And because it is so economical to own and to operate, it testifies to his great practical wisdom. The magnificent 1959 Cadillac will tell this wonderful story about *you*. So delay no longer. Make the decision now and visit your Cadillac dealer. In fact, the car's extraordinary reception has made it imperative that you place your order soon. Why not stop in tomorrow and make the arrangements?

CADILLAC MOTOR CAR DIVISION • GENERAL MOTORS CORPORATION
EVERY WINDOW OF EVERY CADILLAC IS SAFETY PLATE GLASS

Cadillac...universal symbol of achievement

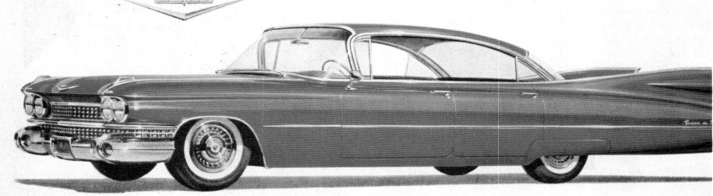

'59 Cadillac

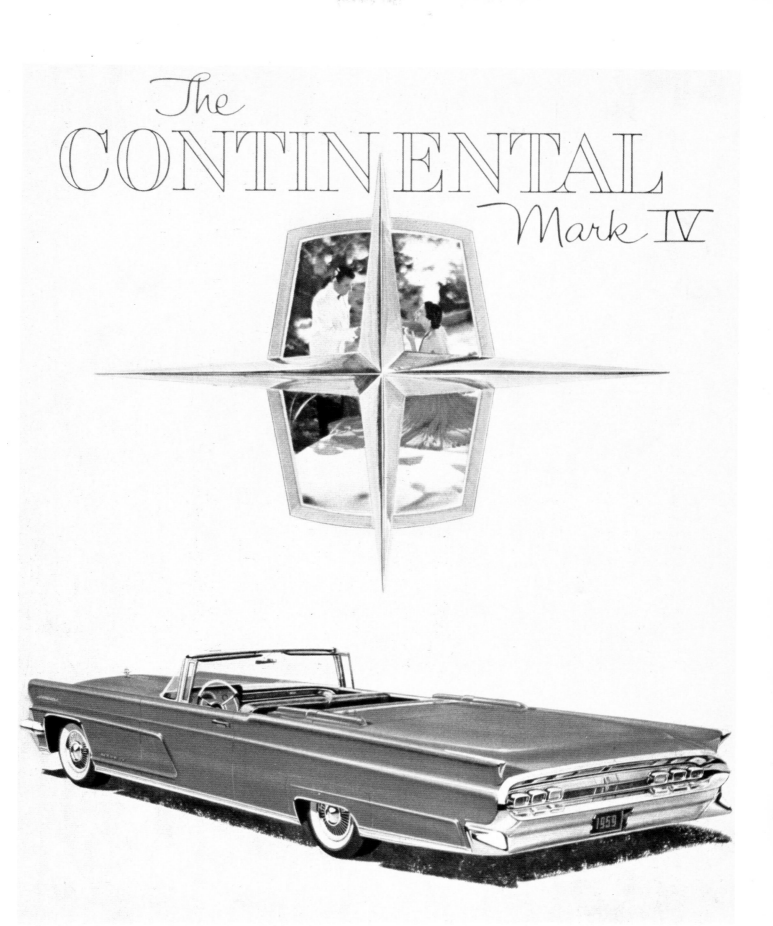

The CONTINENTAL Mark IV

LINCOLN DIVISION · FORD MOTOR COMPANY

"Nothing is more simple than greatness..."

RALPH WALDO EMERSON

'59 Continental Mark IV

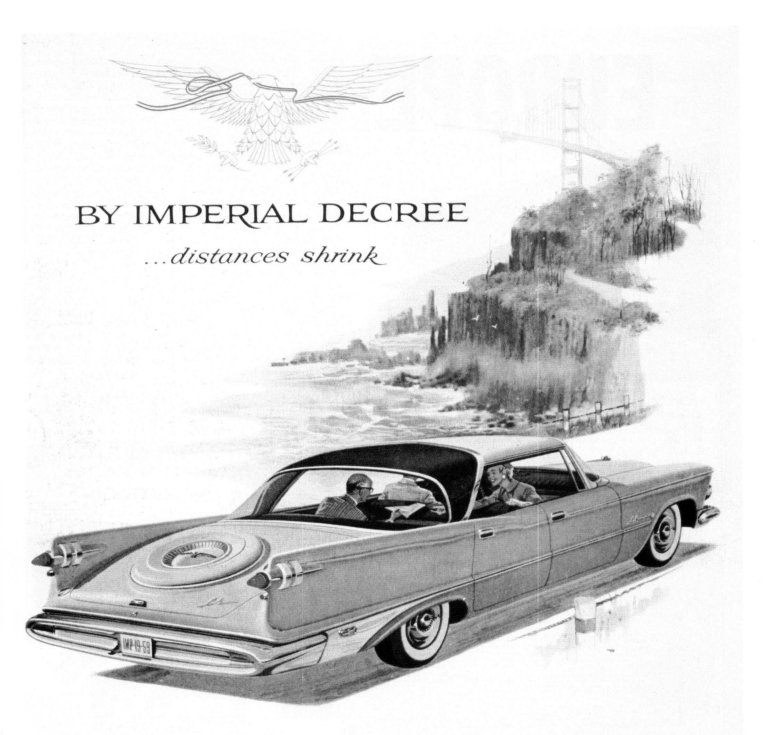

BY IMPERIAL DECREE

...distances shrink

Imperial gives you a wider world to discover, puts far-off, long-dreamed-of sights in comfortable reach.

It's not sheer speed that works this magic (though Imperial has speed you'll rarely use).

It is decreed by the anatomy of the car itself. Seats which mold themselves to the way you sit, which adjust through an infinite number of positions (specially installed swivel seats swing doorward to let you in and out easily). A steering wheel and pedals so deftly positioned that your hands and feet fall naturally into place. Remarkable optional Auto-Pilot that frees your right foot from the accelerator.

It is decreed by the size and silence of Imperial's Royal Coach Body . . . where the loudest sound you hear is the soft and pleasant whispering of the wind. It is decreed by skilled craftsmen working carefully

in America's finest, most efficient automotive plant.

You feel this car a part of you . . . an extension of your own personal driving pattern. It is so restful, so easy to guide and stop and maneuver you can spend hundreds of miles longer at the luxurious task of driving it . . . without fatigue.

When your Imperial is delivered . . . keep in mind that almost nothing will ever be too far away again.

FINEST PRODUCT OF CHRYSLER CORPORATION

IMPERIAL

...excellence without equal

'59 Imperial

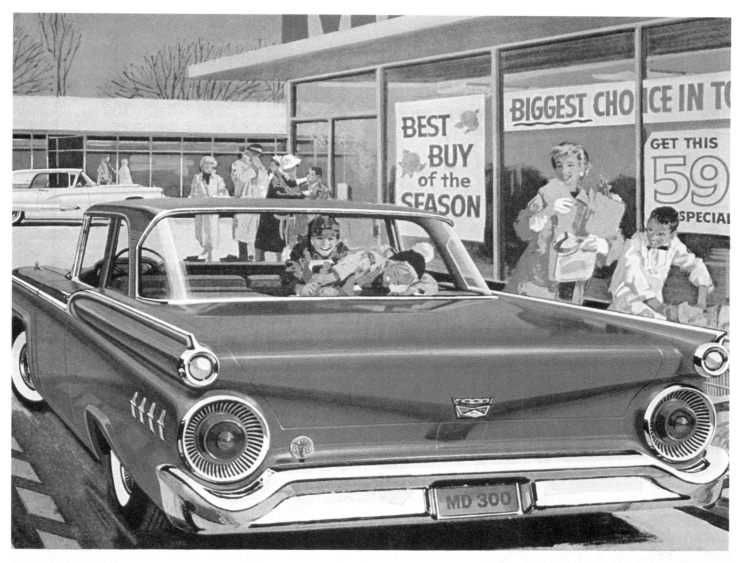

Best buy in the market...

We'll bet you a gross of trading stamps you can't beat this 59 Ford Custom 300 when it comes to value. Styling? Fords are beautifully proportioned for *people*...doors are easier to get in and out of. Inside, there's more space for legs, hips, heads—and hats. Performance? Six or Thunderbird V-8 engines give you peak response at *normal* driving speeds...where you can use it! Economy? Fords use *regular* gas, so you save up to a dollar every tankful. *Savings*, after all, are a Ford specialty. Shop the market...you'll see.

ROOMY 59 FORD RANCH WAGON—LOWEST PRICED WAGON OF THE "MOST POPULAR THREE"

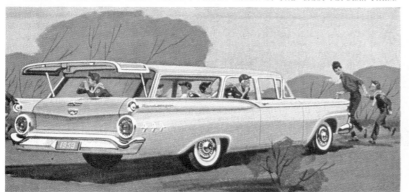

Beautiful new award-winning proportions · Exclusive luxury lounge interiors · New Diamond Lustre finish never needs waxing · Safety Glass all around · Standard aluminized mufflers for twice the life · 4000 miles between oil changes · The most models in the industry · Elegant Thunderbird styling

59 U.S. CHOICE FORDS

WORLD'S MOST BEAUTIFULLY PROPORTIONED CARS

'59 Ford

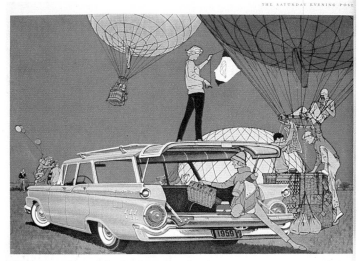

Gas goes a whole lot farther...

Savings reach new heights in this new Ford Ranch Wagon...designed for families living it up on a budget. All six Ford Wagons—Standard Six or Thunderbird V-8—use *regular* gas, save you up to $40 a year on fuel alone! America's wagon specialists have designed them *new*, like a hardtop. Living room comfortable...with sofa-soft seats for up to nine. A stratospheric 92 cu. ft. of cargo space is push-button easy to load with single-operation tailgate. Biggest, most elegant Ford wagons ever. Want a lift?

THE SMARTLY STYLED CUSTOM '59 TUDOR SEDAN...LOWEST PRICED OF THE POPULAR THREE

New award winning proportions • New hardtop styling for picture-window view • All seats face comfortably forward • Safety Glass all around • New Diamond Lustre finish never needs waxing • Aluminized mufflers for twice the life • Full-flow oil filtration takes you 4000 miles without an oil change

'59 FORDS
WORLD'S MOST BEAUTIFULLY PROPORTIONED CARS

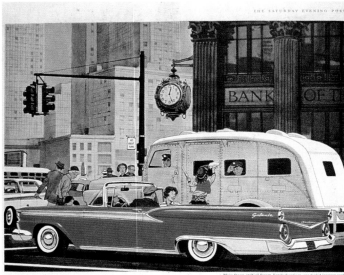

Main Street or Wall Street, Ford's Sunliner says "solid investment"

Safe place to put your money...

Right from the starting price, the '59 Fords save your money. Ford prices start at the very lowest of the most popular three. And you'll find surprising facts like these in your new Ford Owners Manual: "Regular gasoline is recommended for standard engines, Six and Thunderbird V-8...go 4000 miles without changing oil...your Ford muffler is aluminized to normally last twice as long." This same economy manual is yours in any one of Ford's 23 best-selling models. Savings? Ford wrote the book.

EXTRA DIVIDENDS FROM FORD: HULA-HOOP-WIDE DOORS...AND HEAD-ROOM APLENTY

Get extra savings now during Ford Dealer's Dividend Days Share in special saving dividends plus Ford's built-for-people dividends • Full 6-passenger space • Room to wear your hat • Deep springing and cushioning in every seat • Wider door openings for easier in-and-out traffic

'59 FORDS
WORLD'S MOST BEAUTIFULLY PROPORTIONED CARS

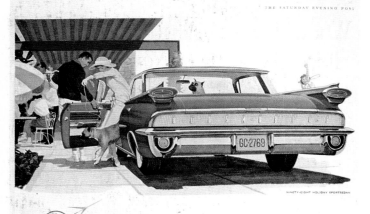

NINETY-EIGHT HOLIDAY SPORTSEDAN

Make a date with the leader . . . Oldsmobile for '59. Its trim, modern style is an open invitation to get out and go. Off and away with a Rocket Engine that's alert and eager. Riding smooth and so secure. Steering was never easier—stopping never surer! It's a wonderful feeling . . . a quality feeling . . . *That Olds Feeling!* And it should (and easily can) be yours. First port of call, your local quality dealer's to take *your* turn at the wheel. OLDSMOBILE DIVISION, GENERAL MOTORS CORPORATION

OLDSMOBILE

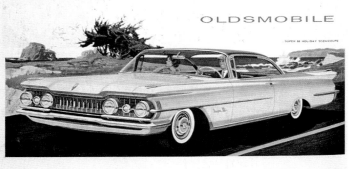

SUPER 88 HOLIDAY SCENICOUPE

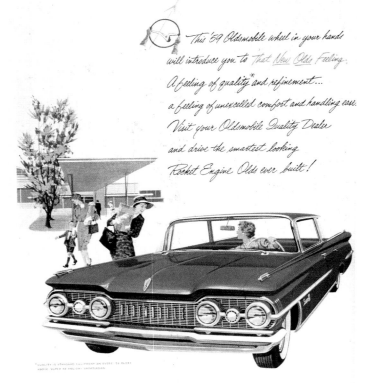

This '59 Oldsmobile wheel in your hands will introduce you to *That New Olds Feeling.* A feeling of quality* and refinement... a feeling of unexcelled comfort and handling ease. Visit your Oldsmobile Quality Dealer and drive the smartest looking Rocket Engine Olds ever built!

*QUALITY IS STANDARD EQUIPMENT ON EVERY '59 OLDS!
ABOVE: SUPER 88 HOLIDAY SPORTSEDAN

OLDSMOBILE

OLDSMOBILE DIVISION • GENERAL MOTORS CORPORATION

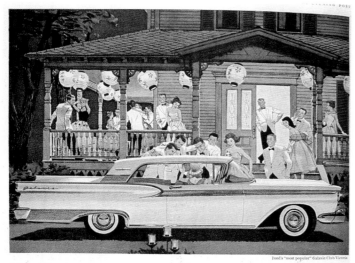

The price of popularity is surprisingly low...

Unwrapped just 6 months ago, the Galaxie is today's most desired car. This figures. For the Galaxie is beautifully Thunderbird in looks, power and luxury... yet typically Ford in its big 6-passenger comfort, low price and never-ending economy. Consider: gas and oil savings *alone* can mount to $55 a year. You save because Ford's Diamond Lustre finish never needs waxing. Surprisingly, the Thunderbird-inspired Galaxie sports a price tag only $50 away from a Fairlane 500 Ford. *Only $50!*

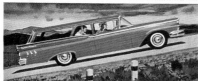

Get extra savings now during DIVIDEND DAYS at your Ford Dealer's. Special saving dividends plus Ford's built-for-people dividends. Deep springing and cushioning in every seat. Wider door openings are easier to get in and out of. Save up to $25 on double-lasting aluminized mufflers.

59 FORDS

WORLD'S MOST BEAUTIFULLY PROPORTIONED CARS

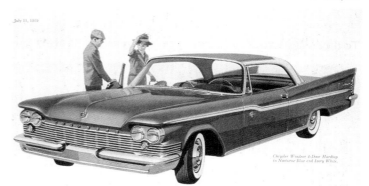

Chrysler Windsor 4-Door Hardtop in Nocturne Blue and Ivory White.

SPACE TRAVEL
...it's pushbutton driving ease with room to spare!

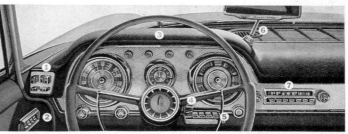

Start your own count-down—at Chrysler's unique control center! **7** Touch button or bar—be with music. **6** Mirror-Matic—flips headlight glare out of your eyes... electronically. **5** Your finger—selects warmth, or air-conditioned comfort. **4** Auto-Pilot selector—dial your speed, push the button, forget the gas pedal. **3** Automatic Beam-Changer—politely dims your lights. **2** Control panel for all windows. **1** TorqueFlite pushbuttons—just touch... and go! There's space-age magic in each of these wonderful Chrysler options. And for the space-minded traveler: hat-wearing, stretch-out roominess for relaxed adventuring. Enjoy Chrysler's quiet, quality ride, too. It's a lasting tribute to Chrysler's rugged construction. Try it yourself. Drive America's most fully automated car...

lion-hearted **CHRYSLER**
...setting the pace in convenience and comfort

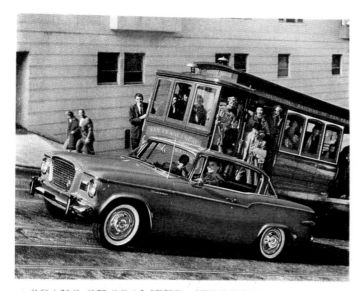

SCADS OF SCAMPER, STUNNING STYLE
MARATHON MILEAGE
COMMON SENSE COST

THE LARK BY STUDEBAKER

➤ Best performance-to-weight ratio of any U.S. car ➤ Best economy-to-performance ratio of any U.S. car; cuts insurance, gas, upkeep and repair costs ➤ More luxury and good taste per dollar ➤ And more inner room to outer size than any car known ➤ WHAT ELSE DO YOU NEED ➤ WHERE ELSE CAN YOU GET SO MUCH OF IT FOR SO LITTLE? Drive The Lark at your Studebaker Dealer's and discover for yourself.

Other models—2-Door Sedan, 4-Door Sedan, Station Wagon. Prices start under $2000. Automatic transmission optional on all models.

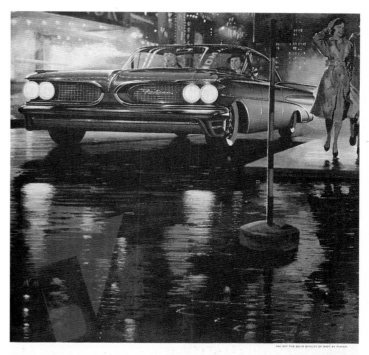

Why Pontiac has captured the imagination of so many, many people
(a very *complete* story)

Why does a person take to one make of car, admire it, talk about it and desire it, yet feel no affinity for all for many others?

The answer, we feel, lies in the *complete* car. The car as a total unit, a composite of *all* the elements of style and operation.

Pontiac this year is winning a *complete* victory as a *complete* car. The sleek, restrained styling has a completely pleasant effect. No gaudy gingerbread. No bizarre bric-a-brac. Just delightful harmony. *Complete* harmony.

Mechanically, it is a most satisfying car to handle and ride in. The Wide-Track Wheel design makes every driving movement easier, more secure, solid. There's a feeling of confidence and authority on Wide-Track Wheels.

Have your nearest dealer bring a bright, brand-spanking new one by your house this week. For the *complete* effect, drive it well and long. (Demand is heavy, but we can have yours to you in time for plenty of summer driving pleasure.)

PONTIAC MOTOR DIVISION · GENERAL MOTORS CORPORATION

THE ONLY CAR WITH WIDE-TRACK WHEELS

Dotted lines show conventional wheel positions. Pontiac's wheels are five inches farther apart. This widens the stance, not the car. Pontiac hugs tighter on curves and corners. Sway and lean are considerably reduced, ride is smoother, balanced, steadier.

PONTIAC! America's Number ① Road Car!

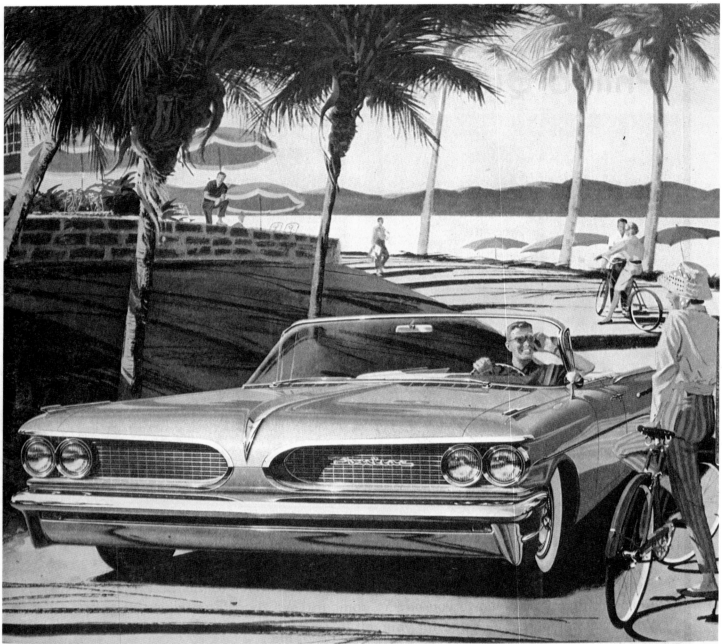

YOU GET THE SOLID QUALITY OF BODY BY FISHER.

Pontiac surrounds a man with beauty
and the solid security of wide-track wheels

We've been noticing something interesting about our men customers. When a man becomes the owner of a 1959 Pontiac he slices a few years off his age, becomes enthusiastic about driving almost anywhere any time, and holds his head a bit higher, a lot more proudly. It's not our imagination. It actually happens.

Unofficial psychology explains it this way: A man who works hard and gives his all to profession and family has earned the right to drive a great automobile. A Wide-Track Pontiac is a perfect reward.

Its trim, sleek lines gratify your sense of good taste and refinement. Yet they're well-defined lines, positive but uncluttered, consistent and clean. The unique grille is a good example; different but highly imaginative and pleasing.

Man is born to be a master and Pontiac gives you masterful control of this car with the security and stability of Wide-Track Wheels; wheels moved five inches farther apart. This widens the stance, not the car. You're balanced, with less lean and sway.

We assure all well-deserving men that this automobile will give you a vigorously fresh outlook on life, a feeling of youth, accomplishment and much, much pride. Show your wife this advertisement; she deserves a Pontiac, too.

PONTIAC MOTOR DIVISION · GENERAL MOTORS CORPORATION

THE ONLY CAR WITH *WIDE-TRACK* WHEELS

Dotted lines show conventional wheel positions. Pontiac's wheels are five inches farther apart. This widens the stance, not the car. Pontiac hugs tighter on curves and corners. Sway and lean are considerably reduced, ride is smoother, balanced, steadier.

PONTIAC! America's Number ① Road Car!

3 Totally New Series · Catalina · Star Chief · Bonneville

'59 Pontiac